REMODELED
HOMES

ROCKPORT

REMODELED HOMES

ETHEL BARAONA

39 Residential Remodeling Projects from Around the World

BEVERLY MASSACHUSETTS

ROCKPORT PUBLISHERS

First published in the United States of America by
Rockport Publishers, a member of
Quayside Publishing Group
100 Cummings Center, Suite 406L
Beverly, MA 01915
Telephone: (978) 282-9590
Fax: (978) 283-2742
www.rockpub.com

ISBN-13: 978-1-59253-509-5
ISBN-10: 1-59253-509-7

Editor and texts: Ethel Baraona Pohl, Liliana Bollini

Editorial Assistant: Marta Serrats

Translation: Cillero & De Motta

Art Director: Mireia Casanovas Soley

Layout: Cristina Simó

Editorial project:
2009 © LOFT?Publications
Via Laietana, 32, 4th floor, Of. 92
08003 Barcelona, Spain
Tel.: +34 932 688 088
Fax: +34 932 687 073
loft@loftpublications.com
www.loftpublications.com

Printed in China

Contents

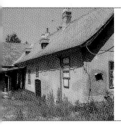

Introduction: Recovering the Sparkle

The architect Albert Tidy

I remember having once read an interview with the famous Catalonian architect, Enric Miralles, given shortly before his untimely death. Amongst several questions of a generic nature there was one that really made me sit up and think: "What would your ideal house be like?" the reporter asked, probably expecting a long, seductive description as an answer. However, the reply was short and categorical: "Second-hand no matter what."

For some time I reflected on the subject and realized that a great many architects I know—myself included—have chosen to live in used buildings that they themselves have renovated, instead of designing a new house right from scratch. This is probably due to three reasons: the first is vertigo, the second is economics, and the third is having the opportunity to value history through an architectural enterprise. In the case of vertigo, this is the paralyzing fear an architect feels when faced with a blank sheet of paper and an arsenal of unedited ideas. For it is much easier to produce a design for someone else rather than for yourself, since the client enjoys the temporary nature of such development and the distance that comes with being observed; on the other hand, the house itself is associated with what is permanent and final, and with the intimacy of the immediate, which are fearful concepts for the spirit of constant creative renovation inherent in architecture.

The second reason why many architects choose to work on an existing building to live in is because of the financial advantages, since a trained eye is capable of discovering things that remain invisible to the disparaging gaze of the majority. Many times, when working on places that are dilapidated or not very attractive—and that have hidden potential—you obtain more for less. That is to say, it is much more convenient to recycle existing spaces than to build them from nothing. The

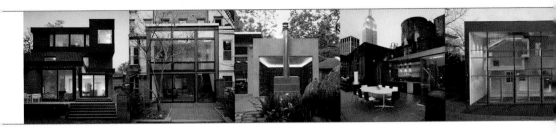

added value these properties acquire thanks to a good design is usually greater than the original investment, making the exercise a profitable business and therefore attractive.

The third reason, and probably the most important of all, is the appreciation of history and the past as an added value in the transaction. Unlike restored cars, architecture is not necessarily interested in freezing time by turning the design into a "historic fake" to get back to the original concept, but rather, quite the opposite: the important thing is to achieve a dialogue between the past and present in a harmonious fashion. The existing "chassis" offers specific possibilities for starting a project. It provides a reference with a number of variables that immediately act as assumptions for design and fields of restriction: if it is very dark, it is given natural lighting; if it is very low, its height is increased; if it is very small, it is extended; if it is very compartmentalized, walls are pulled down; if it is old-fashioned, it is renovated. Nevertheless, all these physical interventions take place simultaneously along with intangible aspects that define the historic value of a property, making them unique, like each of the projects presented in this book.

The value of a house transcends the purely material, since a second-hand home provides a link with its past, with its history. The history of those that preceded us in a particular place of residence, which thus represents a synthesis of the emotions of our own experience. What would become of a home without memories? Is it even possible to conceive of a city without thinking of everyone that lived there before? The answer is no. The city is in essence the framework that remains to accumulate time in its various layers of superimposed architecture. It is a tectonic action in a constant state of flux. As in the case of geological strata, which accumu-

late readings of times gone by to the existence of life itself, apart from its condition as a constructed mass, a city is also the history of the events that gave shape to it.

The great discourse of the metropolis is in turn shaped by the individual discourse of all the houses that lend it cohesion. The house is to the city what the family is to society, since the home makes up the basic and most intimate unit of the urban fabric, which is spread across a wide range of disparity. They come in all shapes and sizes: beautiful and ugly, large and small, decent and degrading, austere and even pornographic. The house in itself provides a family x-ray: it is possible to decipher the visual data it contains that represent the values, tastes, wishes and aspirations of the people forming part of the nucleus that inhabits it. Tell me how you live and I'll tell you who you are.

Time is a condition that adds value to houses. And also to things. It dignifies and reassesses them. An ancient building represents a survivor of the past and is therefore a trove of history. Just like the black box of a commercial jet, inside its walls and enclosures it houses the silent register of joys and sorrows that form part of daily human life. As Octavio Paz would say, "architecture is the untainted witness of history," since it is through its discourse that we are able to read what is not written down but nevertheless dazzles us with greater sharpness than a text and with greater intensity than a story. Inhabiting a place represents the appropriation of space. Inhabiting a place is like getting dressed. Although the clothes cover the body, space, on the other hand, contains it. Inhabiting a place as a home is the most intimate way to humanize space, since the home is that scenario in our private lives where we feel safe and protected, as it represents our refuge for rest and the container of our affections.

Ten years later, while I was doing a master's in architecture at Yale University, I met an eccentric friend. His name was Graham Hunter, a phlegmatic Englishman, who was approaching fifty and easily exceeded the average age of the rest of the students. His life until then had been that of a wealthy banker who occupied a managerial post in a private bank in Frankfurt. One fine day he decided he no longer wished to carry on making more money and wanted to do something that might transcend his own existence. With a cold but practical vision, he observed that buildings lasted as a testimony of their creators and therefore decided to

convene the bank's team of management to announce his resignation. Amazed, they asked him the reasons for his irrevocable decision, to which he replied with surprising naturalness: "I have decided to study architecture because I want to leave something after my death." While we humans measure our life on earth in decades, buildings can do so in centuries, and have an indeterminate number of opportunities to experience the phenomenon of reincarnation. This "resuscitation" phenomenon comes about when the fuctional requirements change or when a property changes hands, or sometimes takes place simply out of the need for re-invention. The school of architecture I studied at in Santiago Chile, was originally designed towards the end of the nineteenth century as a cavalry regiment; it later became a market and also a temporary clinic for victims of a terrible earthquake that struck the city. Before becoming the school of architecture, it was also a girls' secondary school. Throughout the whole of this period, the building experienced at least five "reincarnations," while maintaining its standard of quality and spatial configuration. This is undoubtedly an extraordinary fact that demonstrates the capacity of architecture to transcend its own function to adapt to new uses.

Remodelling a house is no easy task, since it requires engaging a dialogue with the past. Irrespective of the age of the property, in most cases there was a project designer, who planned the spaces before they were inhabited. In this regard it is important to develop the site by means of interventions that can enhance the original values of the project and that in turn can also complement it by evoking a dialogue between the existing and the new. It is surprising to note that, as my friend Graham said, there comes a time when the building takes on a life of its own, and you just have to listen to it to be able to engage it in dialogue and thereby recover its sparkle.

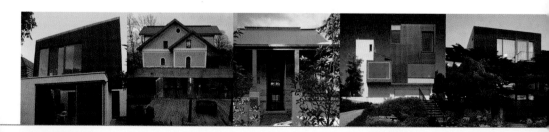

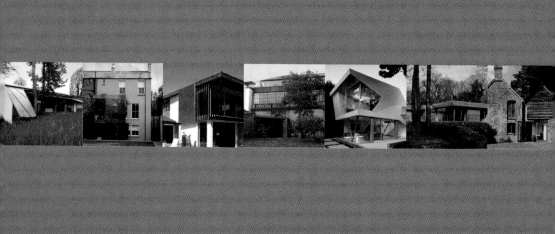

countryside

Alan Family House

Neil M. Denari Architects

Photos © Benny Chan/Fotoworks

■ Los Angeles

The clients of this renovation and expansion project are a couple with three daughters. The design they wanted had to include the creation of a new 1,022 sq. ft. (95 sq. m) space to add to the existing building.

The design involved turning half the house over to the bedrooms of the three girls (including two teenagers) and making the other half, together with the extensions at the front and back, into the public spaces, as well as a private bedroom for the parents. This strategy made it possible to add a 16 foot (4.8 m) deep space to the existing construction.

Some of the walls were moved to add a second bathroom, give each girl her own room, and open up a space that acts as a dining room, which leads onto to a spacious kitchen.

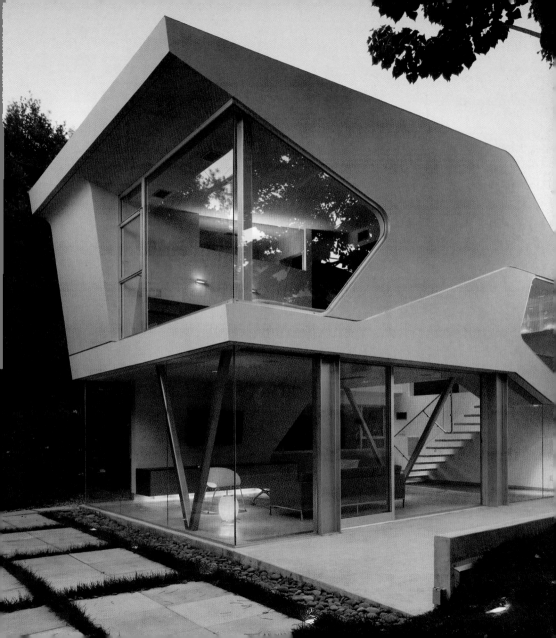

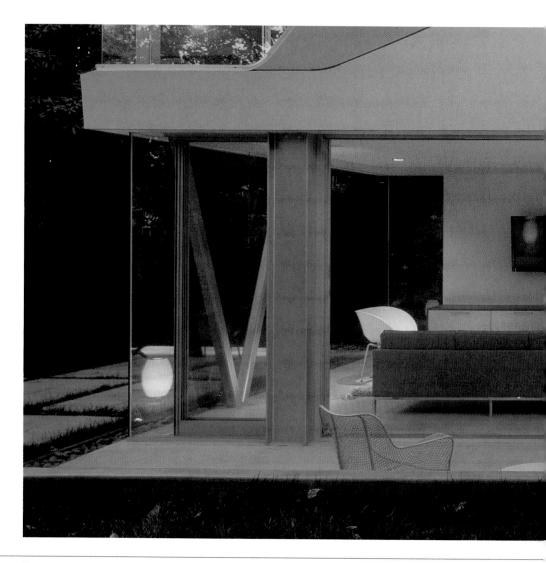

The new lines form a sharp contrast with the existing house, sparking up a remarkable interaction between the shapes and materials from both periods.

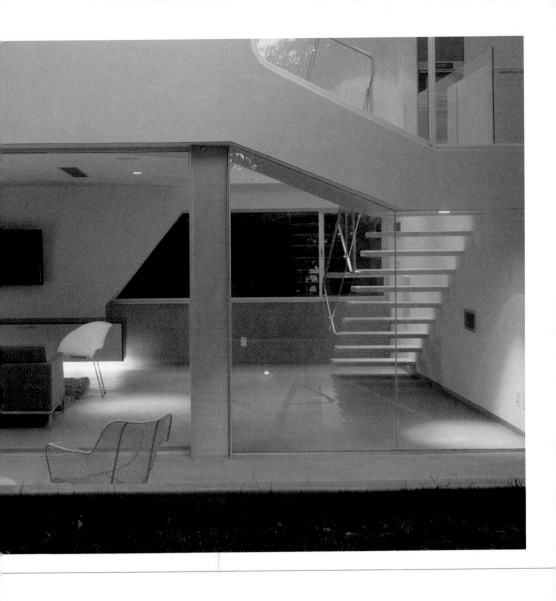

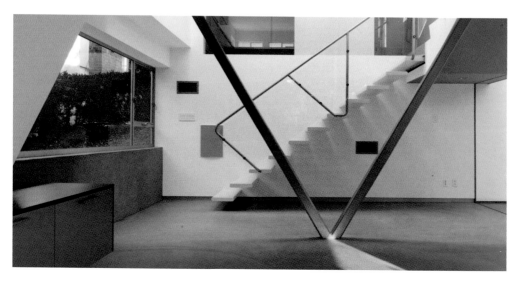

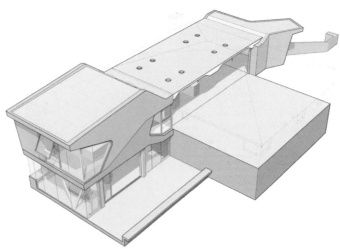

Axonometry. The axonometric, or three-dimensional view, makes it possible to see the whole of the extension of the property, both at the front and out the back. It also shows the color scheme used.

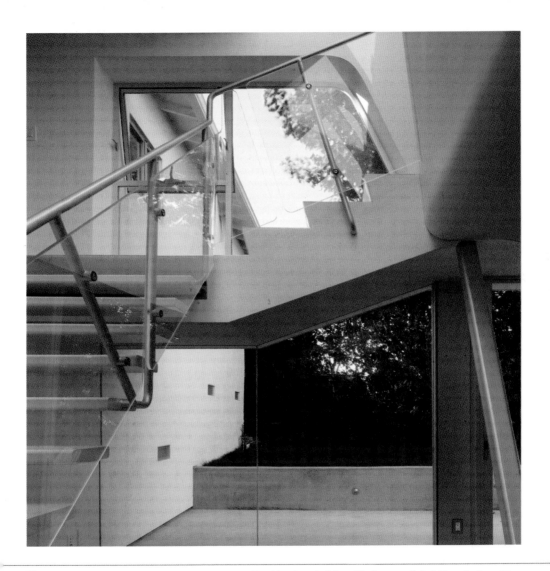

The staircase with skylight serves as a bridge between the old and new buildings. The three small skylights make it possible to enjoy natural light throughout the home. Of note is the play of geometrical shapes formed by the staircase and skylight.

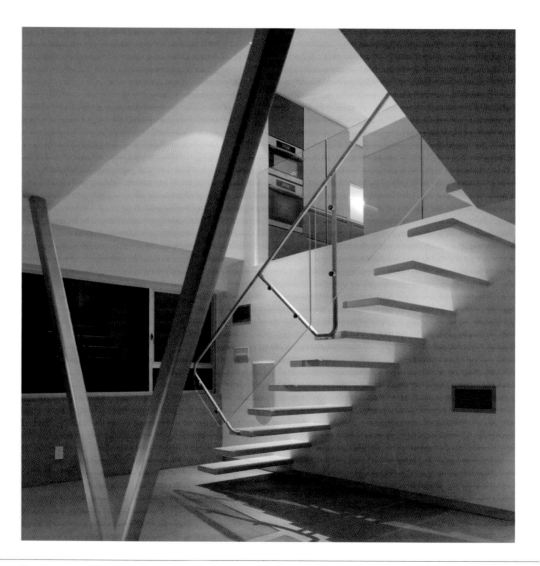

A dramatic projecting staircase leads to the master bedroom. It is characterized by the display of structural steel, a fixed handrail also in steel and glass, and a poured concrete floor.

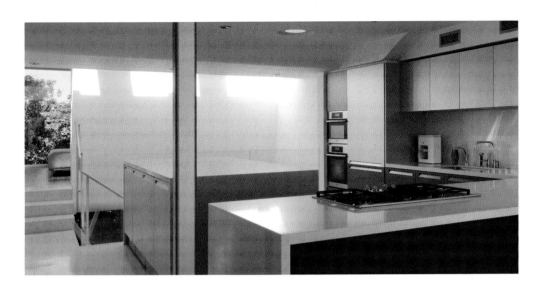

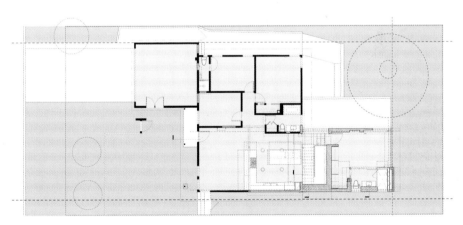

Floor plan. It clearly shows the existing walls (black) as well as the new ones (gray). The areas most affected by the remodeling work were the kitchen, the stairs, and the new bedroom found at one end of the property.

Costa Mesa House

Techentin Buckingham Architecture, Inc

Photos © Techentin Buckingham Architecture

■ Costa Mesa, California

The owners of this single-family residence in Orange County, California, a couple with four children, had one very simple requirement: they needed more living space. With this in mind, it was agreed that a priority would be to add at least two bedrooms, a bathroom, and a study area.

As well as additional space, the family had a particular interest in making sure the interior and exterior were well connected. The relationship between inside and out is shored up with a design that avoids closed spaces, favoring visual continuity throughout.

Highlights of the new work include the draped ceiling and the contrast between the white walls and the dark tones of the columns and banisters.

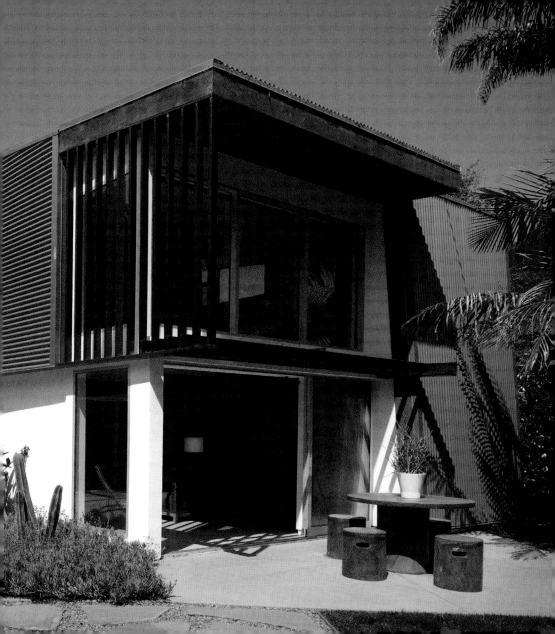

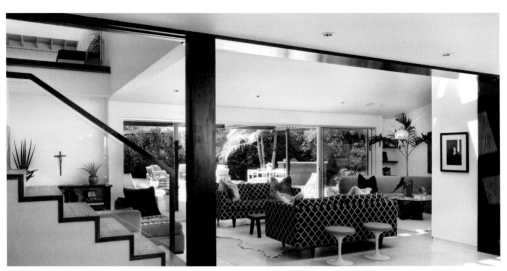

Exploded view. The diagram clearly shows the reform work done on the home: the new spaces (sky blue) and new surroundings (red) can be appreciated on the original white ceiling.

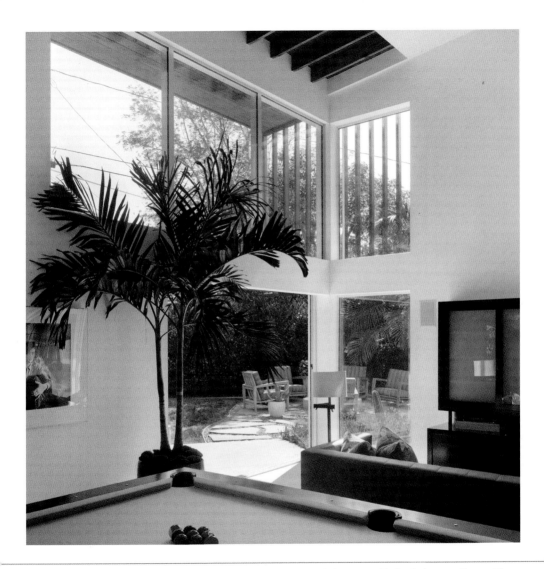

■ A new living area was created in which the highlights include the armchairs arranged in front of one another and the natural lighting that penetrates through the draped ceiling, leaving the wooden beams exposed.

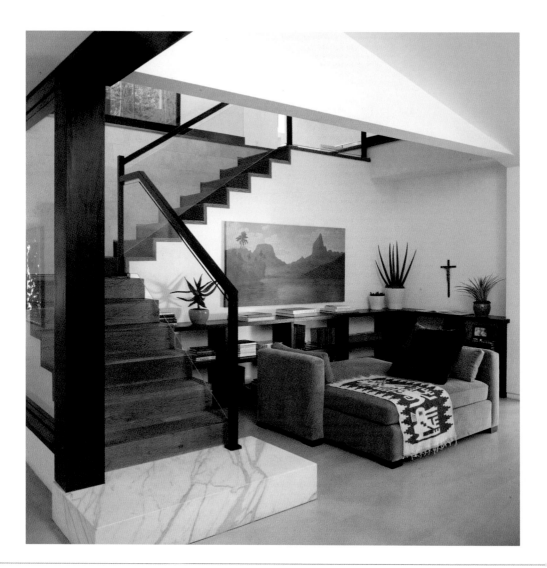

A staircase with two sections, covered in wood and with painted structural iron rails and transparent acrylic panels, surrounds the living room, which was added following the extension.

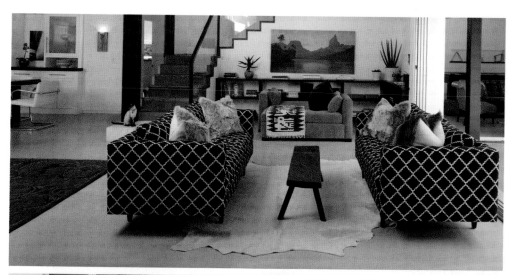

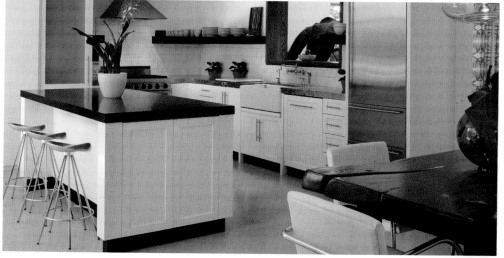

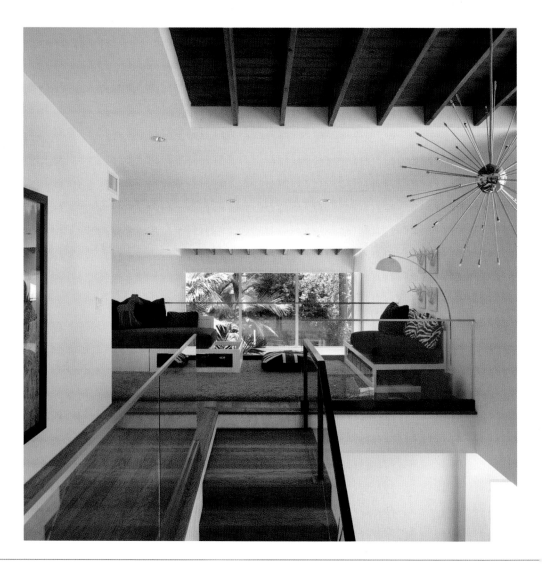

On the second floor, the master bedroom, added as part of the reform work, has a sloping ceiling in which the only detail is the beams. This resource is repeated in various parts of the home, giving it a unique identity.

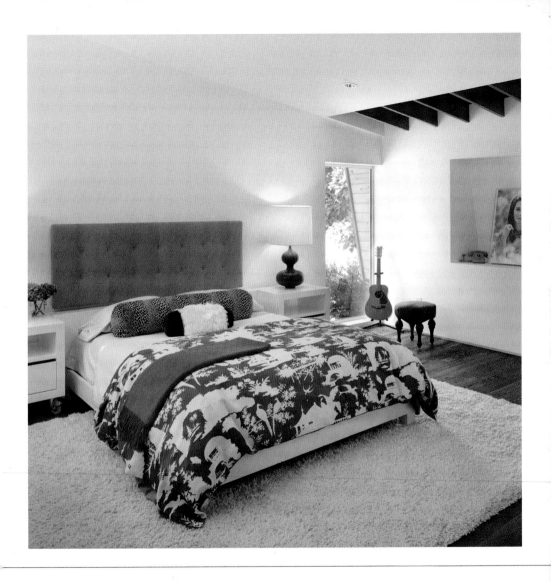

Los Feliz House

Techentin Buckingham Architecture, Inc

Photos © Eric Staudenmaier

■ Los Angeles

The house is in the Los Angeles neighborhood of Los Feliz and was built in the 1920s. Since then, many of the local properties have been turned into small apartments due to property shortages in the area.

The home's design makes the most of the views and at the same time maintains the owners' privacy. To achieve this, the architects used diverse strategies, the first being to underline the relationship between the exterior and interior, putting in new windows of very different sizes and positioning them in strategic spots in the façade; a second idea, based on Dutch design theories, consisted of creating a network of interior spaces, separated but at the same time interrelated.

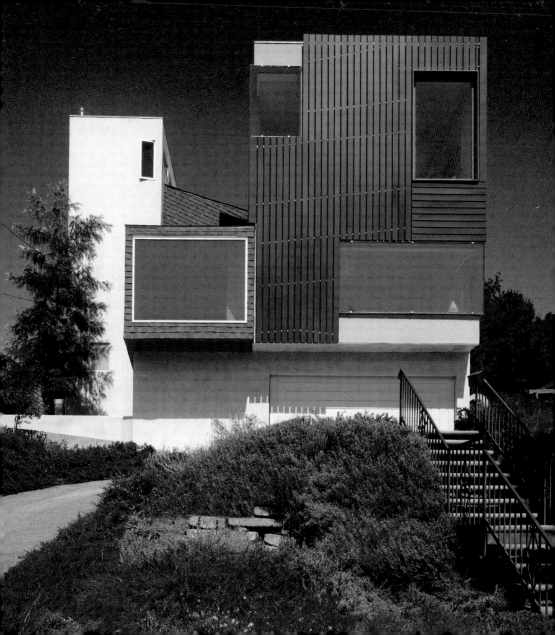

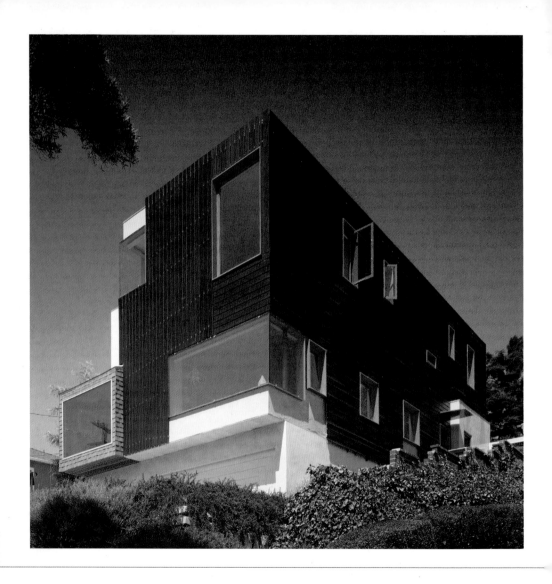

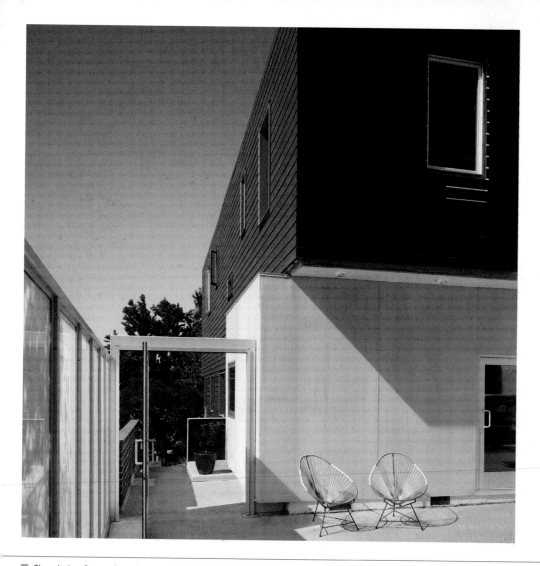

The window frames have been painted green to create a strong contrast with the dark wood surface.

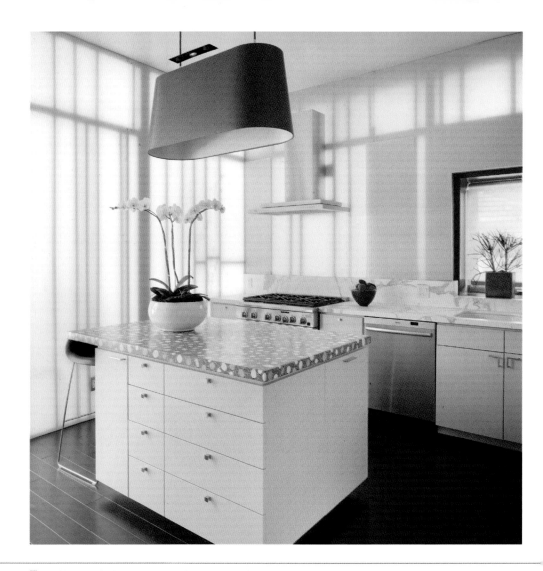

The kitchen, with its translucent walls, contrasts noticeably with the dark wood chosen for the exterior.

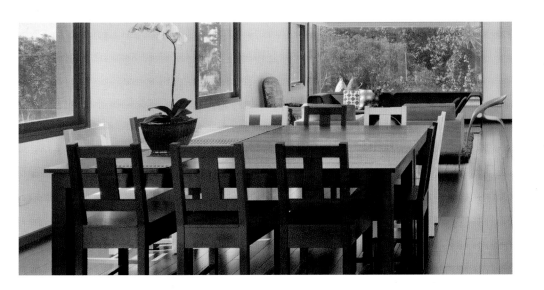

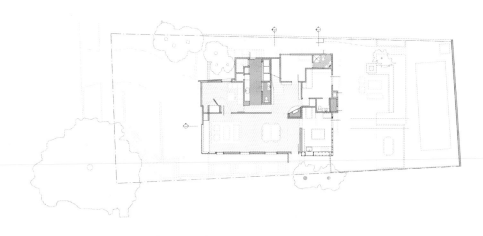

First floor plan. The living and dining rooms occupy a completely open-plan space on the first floor with views to the outside.

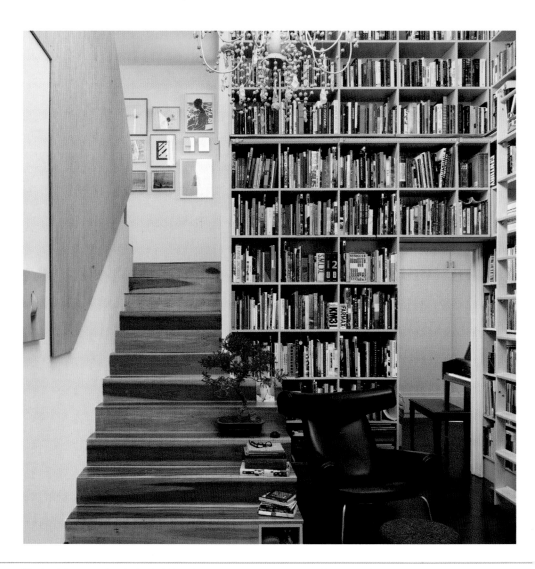

The stairs generate a double height, which has been taken advantage of to make a library.

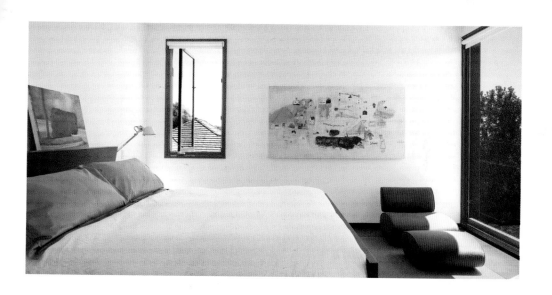

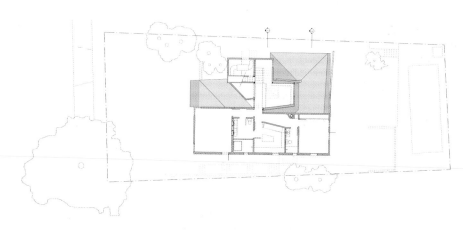

Ground floor plan. On the ground floor, all the rooms face outward to enjoy the landscape. The bathrooms are in the middle.

Dijkmeijer House

UArchitects

Photos © UArchitects

■ Aarle-Rixtel, The Netherlands

An expansion and remodeling project usually involves an important challenge, given that one usually has a limited budget and, sometimes, problems involving historic preservation.

In the case of Dijkmeijer House, the façade was left intact to not alter the view from the street or the urban integration. The extension out the back had to include spaces for a kitchen and dining room on the ground floor, along with a bedroom and ensuite bathroom upstairs. The old part was also remodeled, creating three new rooms and a study, with an optimal use of space.

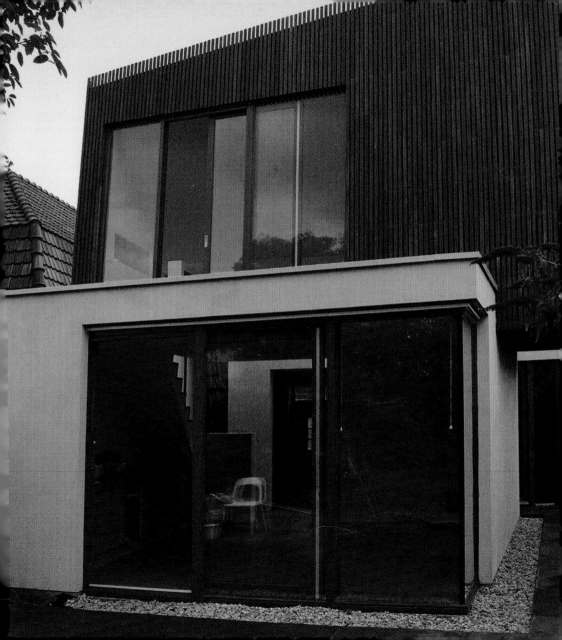

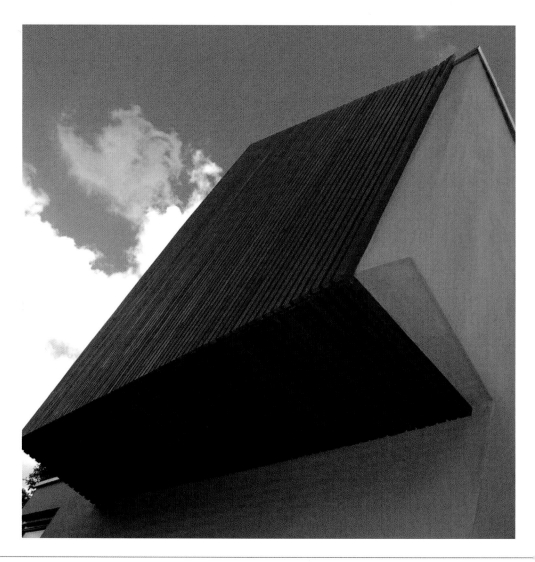

The woodwork upstairs makes up the covering of the new bedrooms and serves to protect them from the sun.

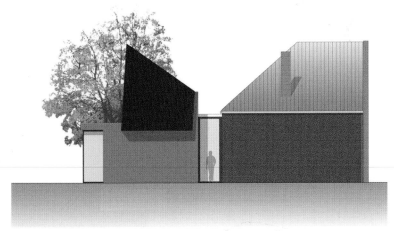

Front façade. Here one can see the whole of the rehabilitated main façade. The new part features the wooden lattice work for the bedroom area which helps to regulate the sunlight.

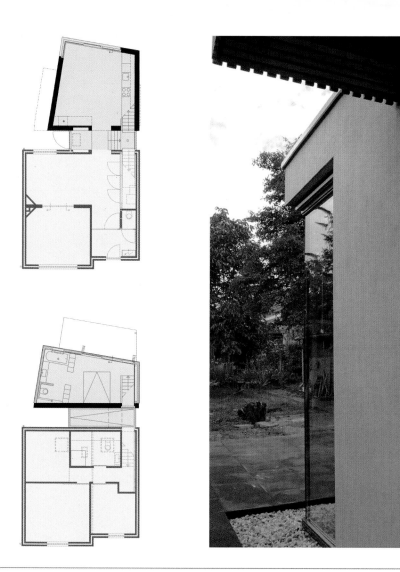

■ Ground floor and first floor plans after the reform. Both plans show the new walls (black) put up in the demolished area at the rear of the property.

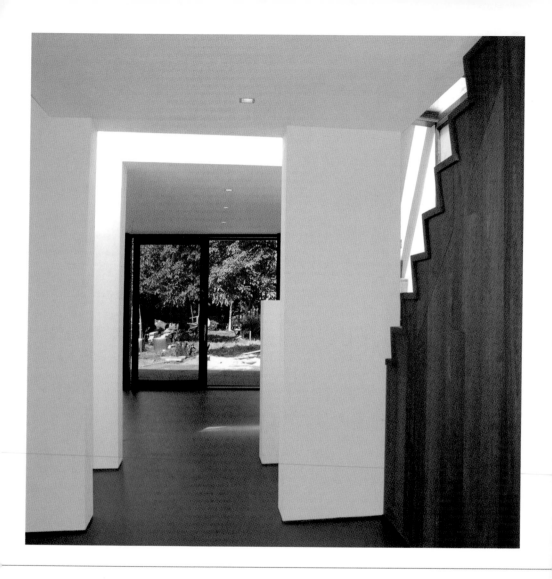

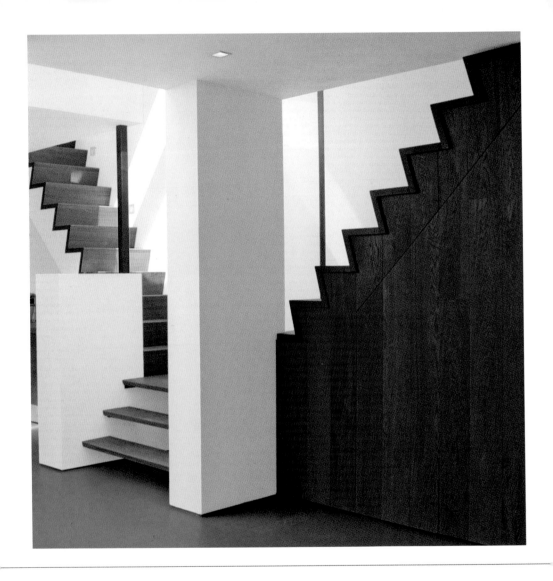

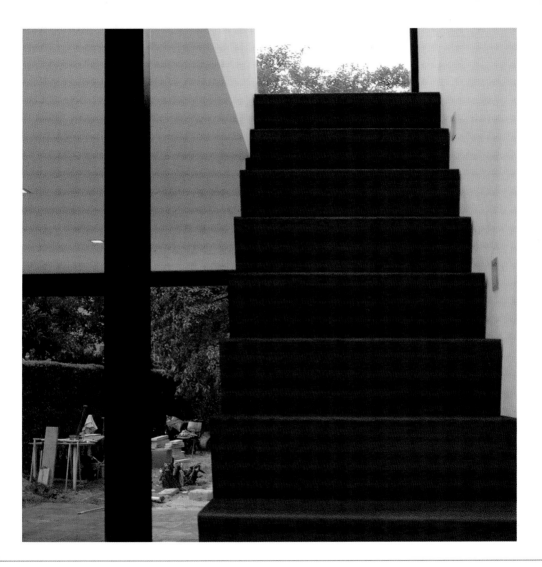

■ The entry of daylight is especially important in this zone, as it emphasizes the contrast between the white and brown of the staircase.

Private Retreat Hadersfeld

Syntax Architektur

Photos © Klaus Pichler, Syntax Architektur

■ Hadersfeld, Austria

This ambitious project turned a nineteenth-century inn in a small town near Vienna into a family home. The owners wanted to conserve the spirit of the place and maintain the tradition of opening it up to the townspeople once or twice a year. To achieve this, two different tasks were undertaken. First the existing property was restored and then the expansion built.

The new volume has been carefully constructed among the old trees. Meanwhile, the revamped building offers the best views and optimal use of the garden. Both volumes, connected by the entrance hall, comprise a public space and private zone. The very cold winters and hot summers typical of the area made thermal insulation a fundamental part of the new design.

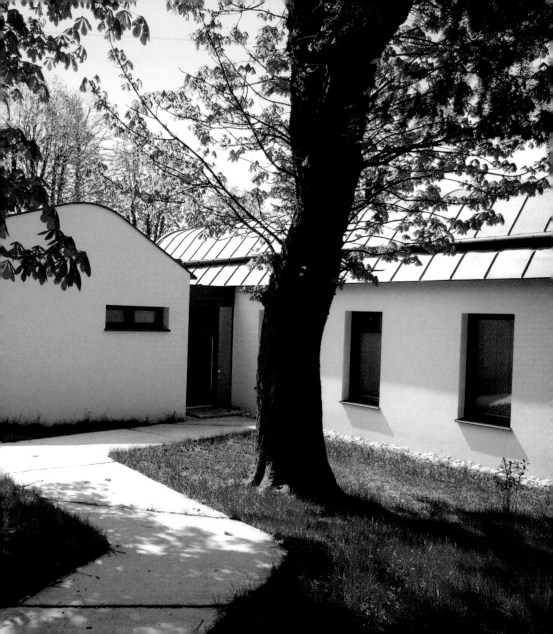

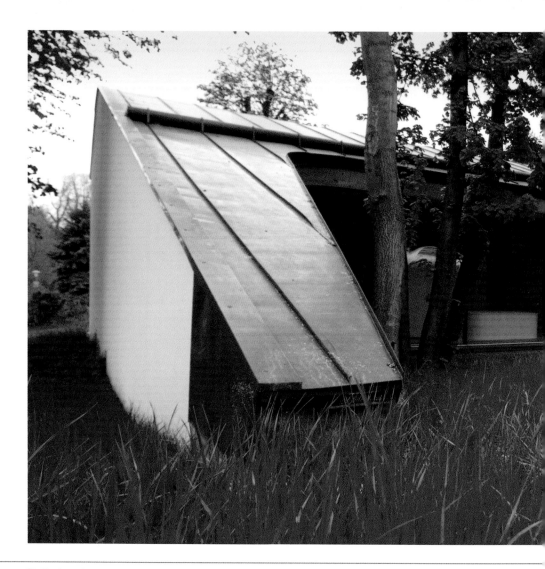

The irregular shape of the lot gave rise to this design of groundbreaking shapes.

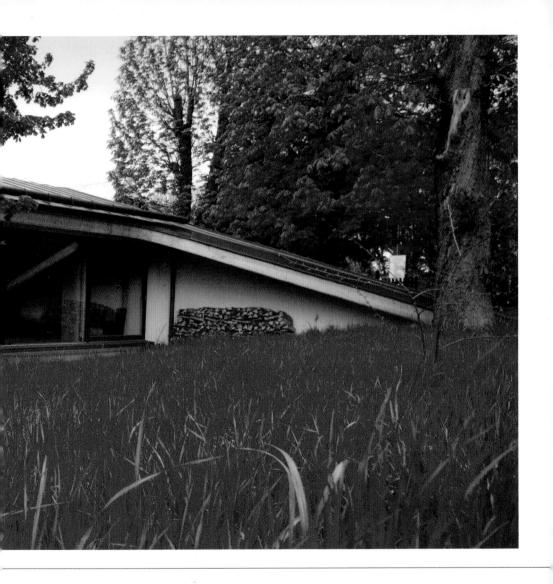

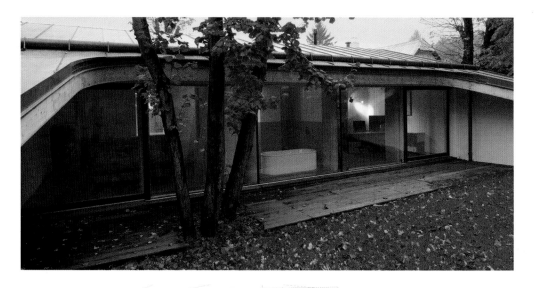

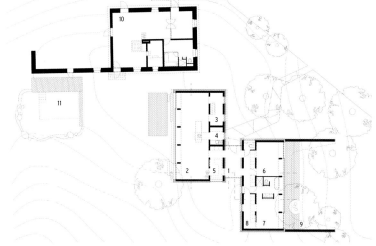

1. ENTRANCE HALL
2. LIVING ROOM
3. LIBRARY, STAIRCASE
4. KITCHEN
5. BAR
6. STUDY
7. BEDROOM / BATHROOM
8. CELLAR
9. BALCONY
10. RENOVATED WORKSHOP
11. POND / POOL

Ground floor plan. The ground floor shows the rehabilitated home and the two new blocks of the extension, as well as the way they adapt to the slope of the land.

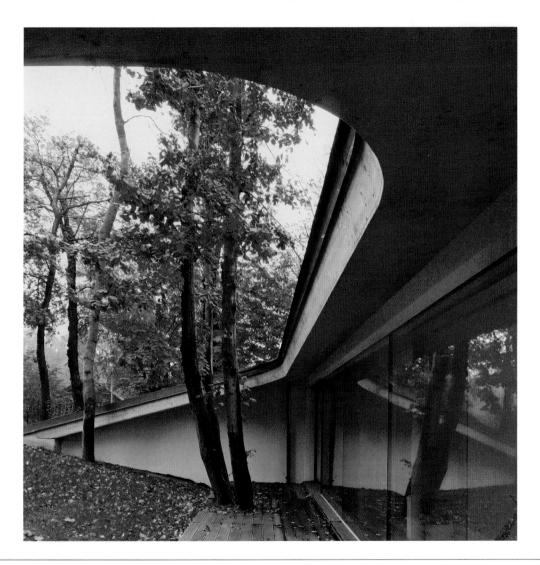

The roof seems to be an almost natural continuation of the slope of the plot. Diverse materials and construction methods were studied to obtain the desired roof shape.

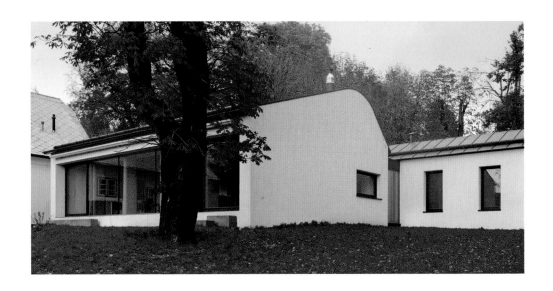

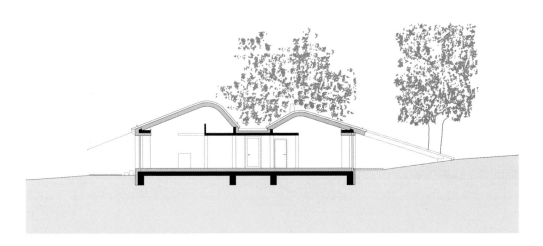

Cross-section of the buildings constructed as part of the extension works. The laminated wooden beams and large roof protect the inhabitants from the sun during the summer months.

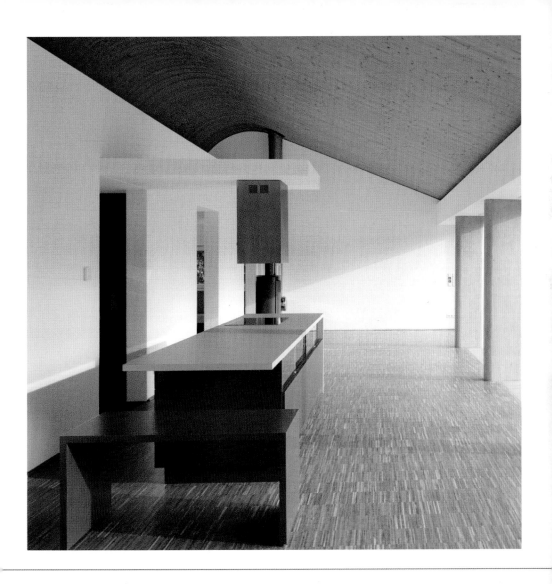

San Juan House

José María Sáez

Photos © José María Sáez, Raed Gindeya

■ Quito, Ecuador

This property is located in the historical center of Quito. The central axis of the project is an interior garden built in an old courtyard, which has become the connection point between the interior and exterior spaces.

A large metal beam was used to shore up the façade and visually link the home with the horizontal-style garden. This detail—technically complicated in principle—formed the basis of the design and was emphasized with simple and resistant joints. The deck permits a wide range of ways to enter the garden, in line with the owner's requirements. The living room could now recover its initial condition of a terrace. Inside, the hall is the heart of the home.

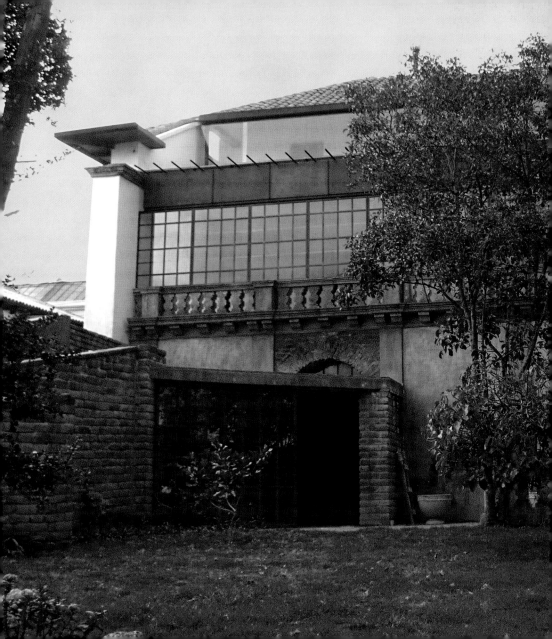

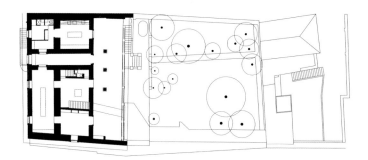

■ Ground floor. The ground floor, with common areas such as the kitchen, where the balcony emerges that looks out over the garden.

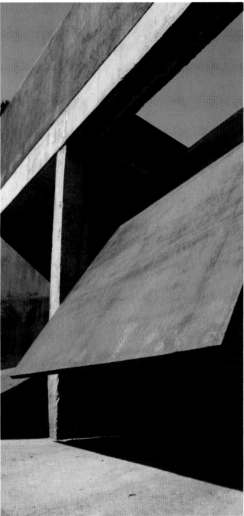

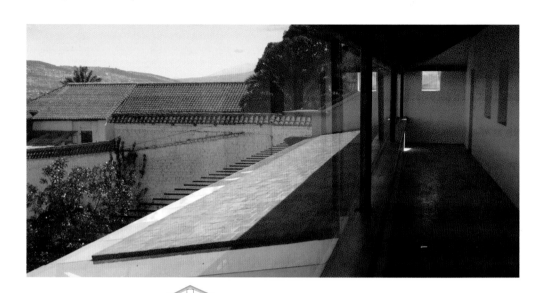

Cross-sectional view and floor plan of the home prior to the intervention.

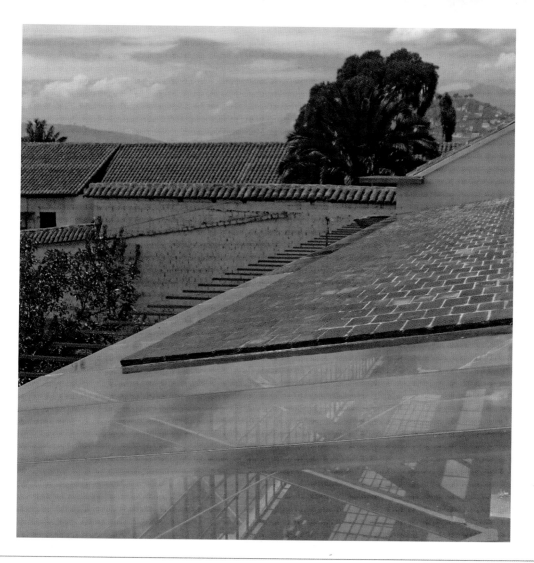

A large metal beam, which supports the mobile windows, was used to glass in the 60 foot (18 m) façade. The same beam is also used to support the glassed-in balcony roof, which permits the entry of abundant light.

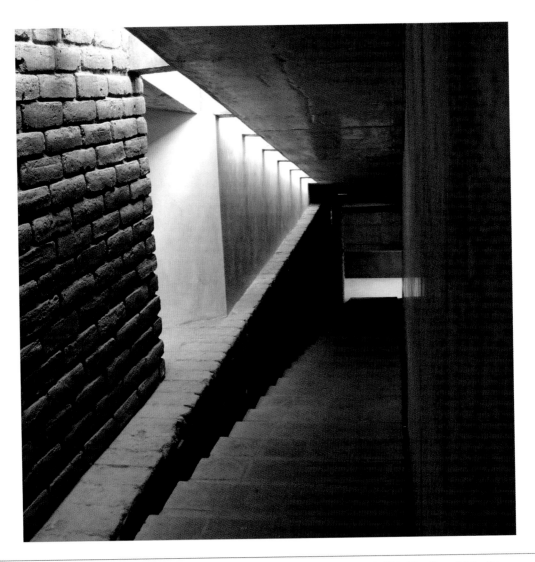

The passage that joins the balconies with the rest of the house, built in concrete and with brick walls, maintains the stony character of the whole of the lower part of the building.

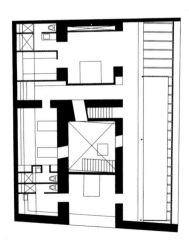

Upper floor plan. The bathrooms and bedrooms have been done up on the top floor and the façade glassed in.

Villa under Extension

Ofis Arhitekti

Photos © Tomah Gregory

■ Bled, Slovenia

This project consisted of the extension of a nineteenth-century villa located in a beautiful alpine hotel next to Lake Bled, Slovenia.

The main requirement of the client was to double the space of the existing living areas and at the same time make the most of the views over the lake. The groundbreaking project design consisted of positioning the new spaces (kitchen, dining room, living room, library, and study) in a new extension beneath the ground floor of the pre-existing villa. This gained 7,500 sq. ft. (697 sq. m) of inside space, while respecting the original construction and surrounding landscape at all times.

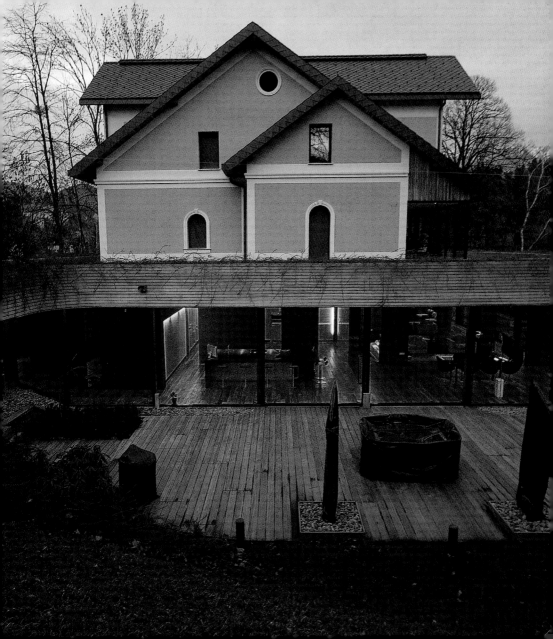

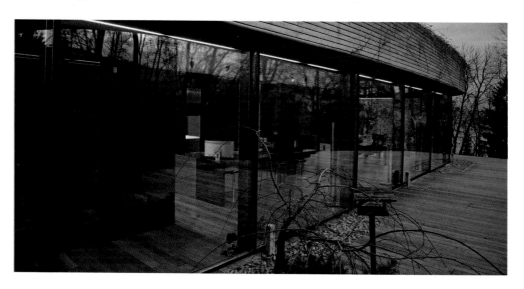

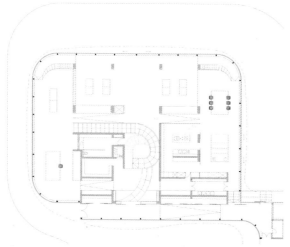

Ground floor plan. The plan shows the glassed-in perimeter and the curved corners that match the surroundings. This plan in particular shows the importance of the staircase as a central design axis.

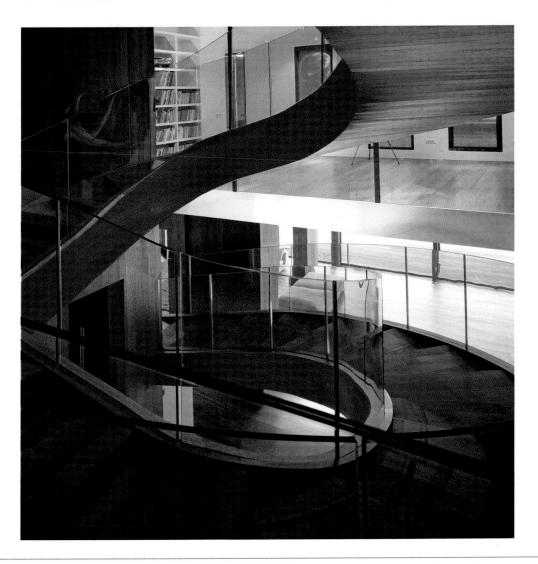

Vertical axis of the stairs seen from the first floor. The new building and old villa are connected by this spiral staircase, which can be reached from every room.

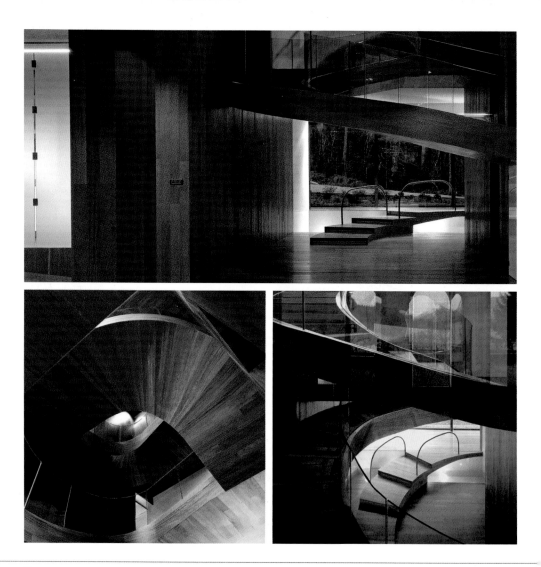

The spiral staircase configures the hall in the extension, as the entrance to the property is beneath it. The position of the house next to the lake and in the middle of a forest makes this villa unique.

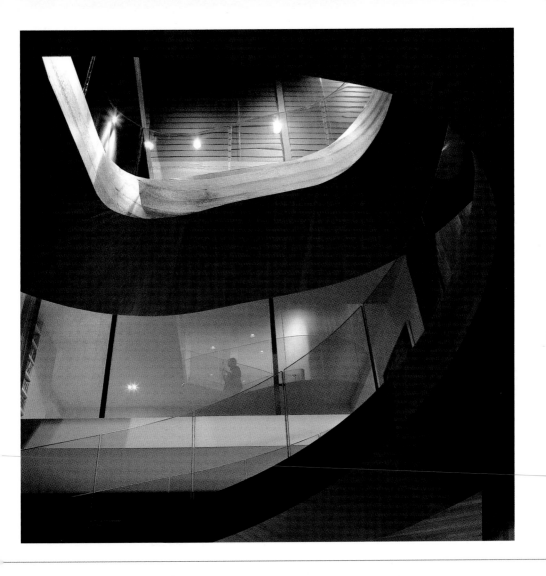

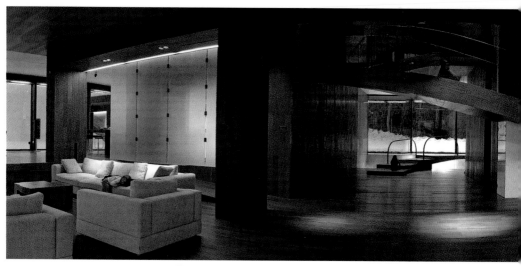

Diagram. Schematic diagram of the extension under the existing building, taking the topography and landscape that surrounds the villa into account.

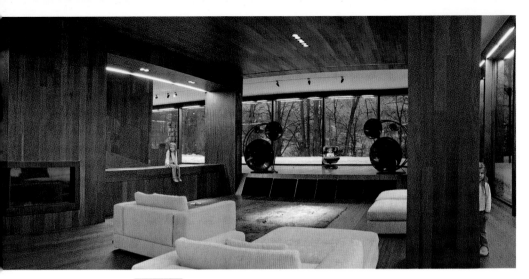

■ Diagram. Diagram of the circulation inside the extension: one can appreciate the organic design and fluid connection between the spaces.

Fink House

Ian Moore Architects

Photos © Brett Boardman

■ Sydney, Australia

This project consisted of the renovation and expansion of an 1840 stone and sandstone cottage that had already been the object of a substantial expansion in 1980. Because it is a historic-preservation building, neither the façade nor any other visible part that would remain above the current roof line could be modified.

The inside of the house, including the sandstone walls, was in a poor state, so the decision was made to cover the walls up with custom-made plaster panels.

Almost all the interior partition walls had been eliminated in the 1980 renovation, but this time around the intervention involved the construction of a bridge over the garden to connect the master bedroom, above the garage, with the rest of the property.

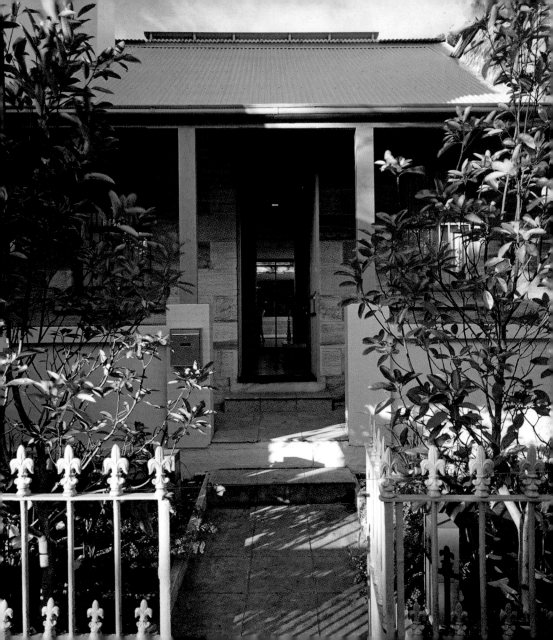

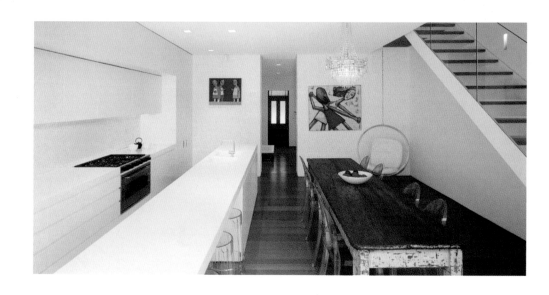

Floor plan. One of the main goals was to integrate the courtyard and garage into the main space in order to make the interior look bigger.

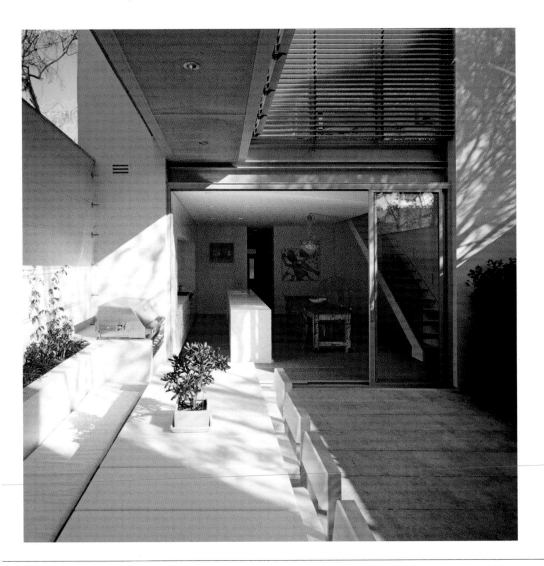

The spacious kitchen, which looks onto the garden through the large windows, is also used as a get-together point for the whole family. The work bench is made from synthetic resin, painted Hi-Macs white.

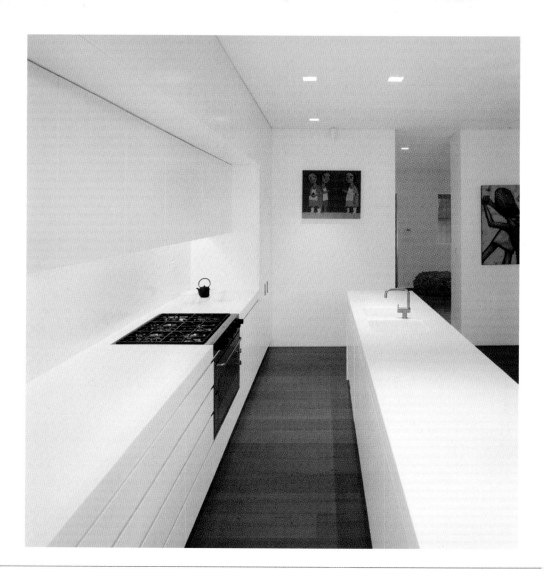

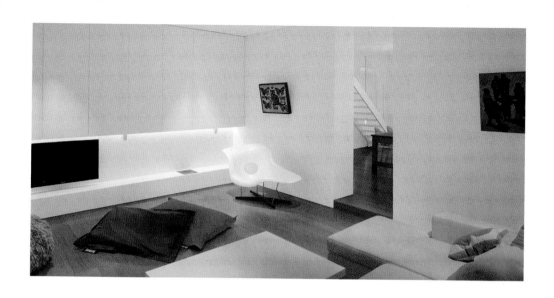

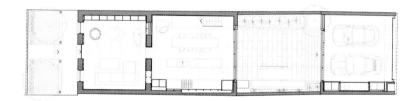

■ Ground floor plan. The lower level is divided into four square spaces that make up the living room, kitchen/dining room, courtyard, and garage. The three bedrooms and the bathrooms are upstairs.

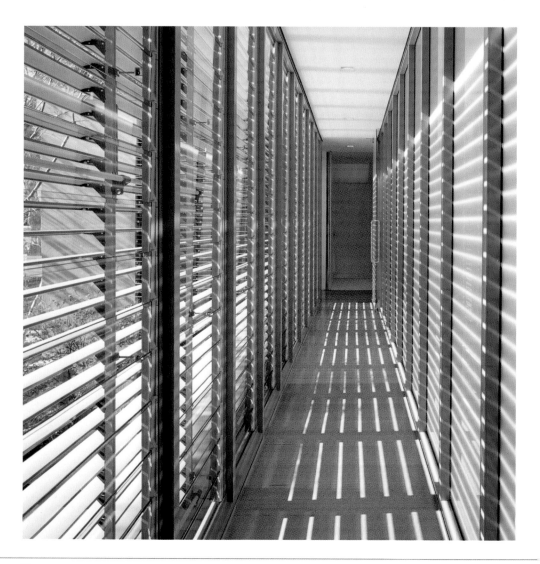

The natural ventilation using glass shutters, the large glass sliding doors, the aluminum sunshades in the windows, and skylights make this home a sustainable building.

Castle in Leimental

Buchner Bründler AG Architekten BSA

Photos © Wehrli Müller Fotografen

■ Leimental, Switzerland

The word "castle" evokes numerous images: the magic castle of fairy-tales, the impregnable feudal lord's home, the capricious summer residence of kings. This castle, located south of Basel on the top of a mountain and with splendid views across the valley, covers them all.

The restoration work left the exterior almost completely intact, as the site, a former Roman settlement, was nothing less than a historical symbol of the place. Over the years, the castle has functioned as a sanatorium, restaurant and even a mink farm. The base of the remodeling consisted of creating a 1,500 sq. ft. (139 sq. m) space which would function as a loft and could adapt to the requisites of modern life.

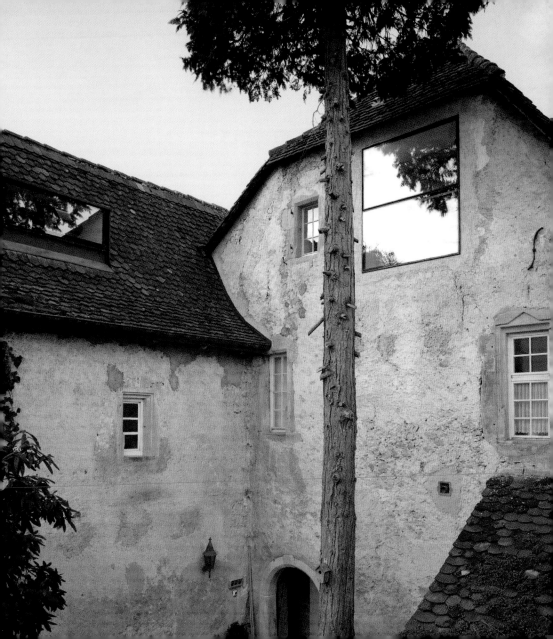

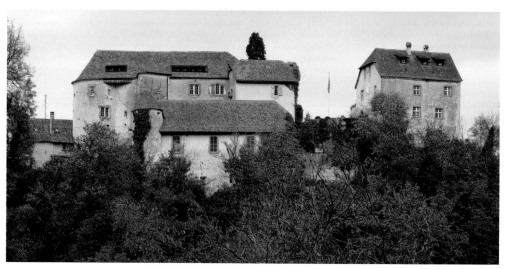

Elevation. The elevation clearly shows how the windows are perfectly integrated into the building as a whole.

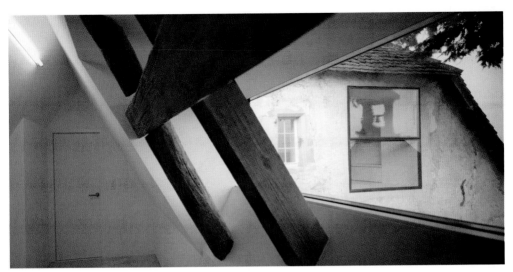

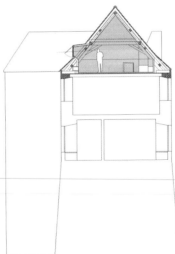

Cross section. This cross-sectional view shows the work done on the wooden ceiling structures.

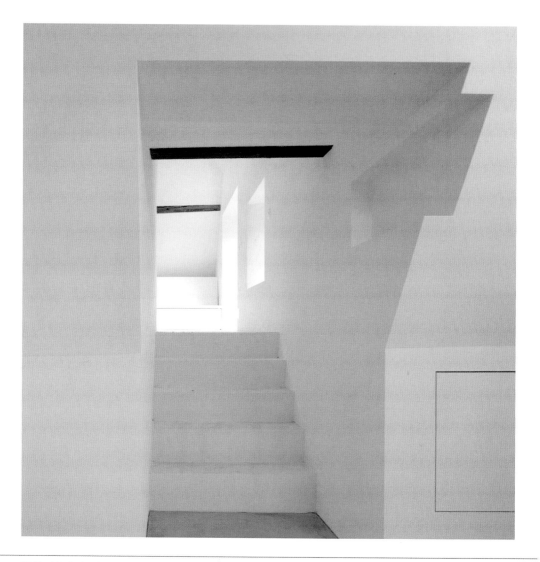

■ The interior has been covered with lime mortar, making it sparkling white and able to reflect the sunlight in all the rooms. In the 82-foot (25 m) long space at the top, the dark wood on the white lime-mortar surfaces affords an attractive contrast.

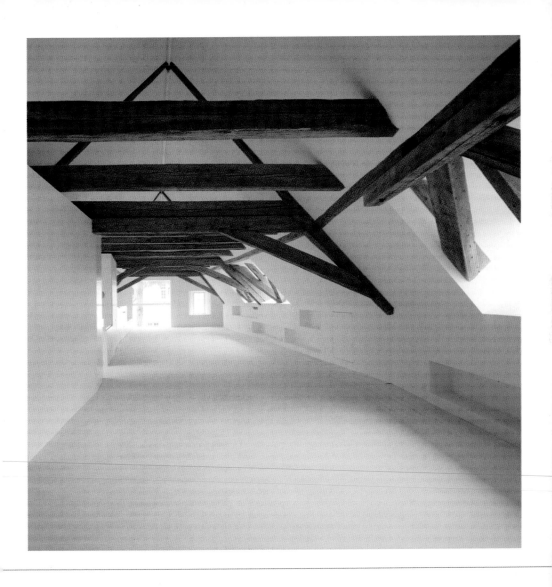

House H

Bevk Perović Arhitekti

Photos © Miran Kambič

■ Ljubljana, Slovenia

House H is located in a privileged corner of Rona Dolina, a residential neighborhood of Ljubljana, Slovenia. In both the renovation and the extension of the property, the architects worked with the aim of integrating the existing 1960s structure with the external landscape.

The new pavilion, an independent volume located in the garden, is used as an additional living room that functions as a space halfway between the house and the outdoors. This structure, built with a reinforced concrete shell, appears to float above the ground and reflects the garden, integrating it with the landscape. The floor plan responds to local building requirements to separate new structures from the edges of a plot by a minimum of 12 feet (4 m).

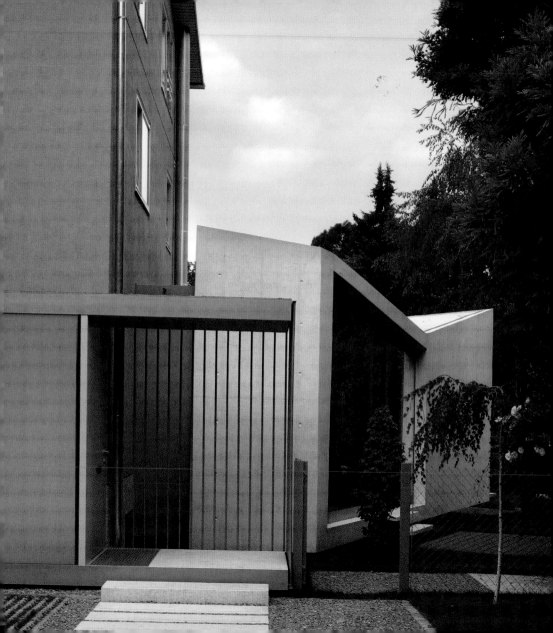

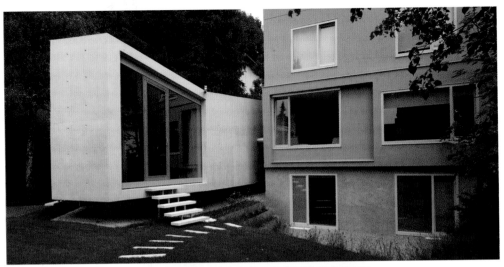

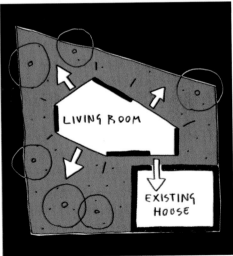

The glassed-in areas and wooden window frames facilitate the building's integration with the garden. Upon entering the home, visitors find a small pavilion which reflects the surrounding garden as if it were a mirror.

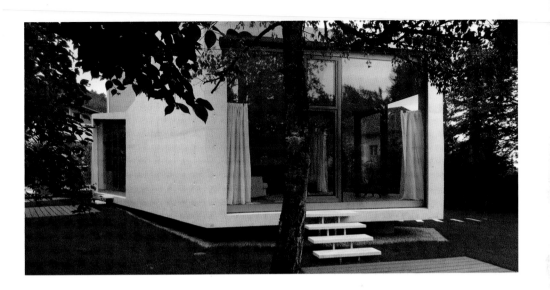

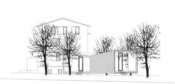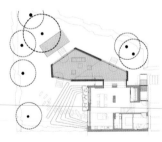

Elevation and floor plan. This elevation shows how the structure plays with height and glass to create a relationship with the existing property.

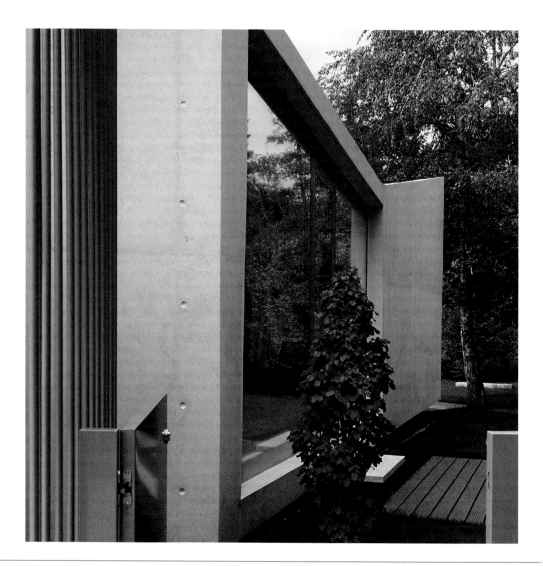

The glassed-in areas and wooden window frames facilitate the building's integration with the garden. Upon entering the home, visitors find a small pavilion that reflects the surrounding garden as if it were a mirror.

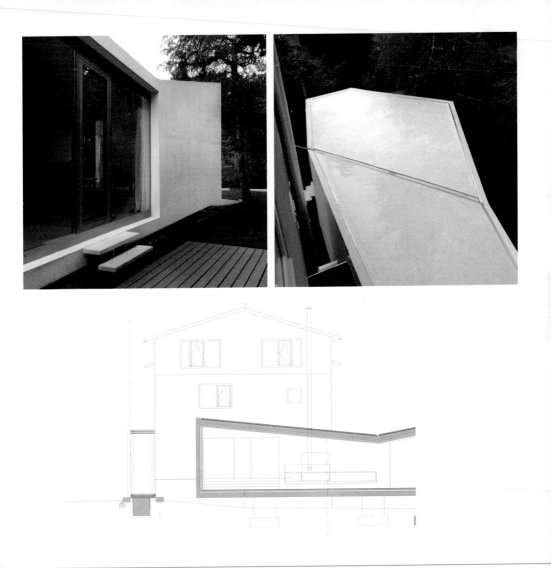

Partial section. It shows in greater detail the piles that support the module in order to free up the land.

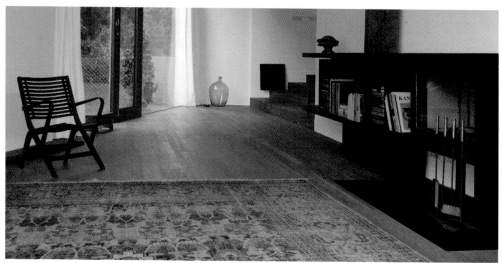

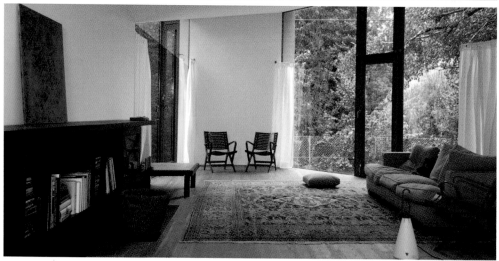

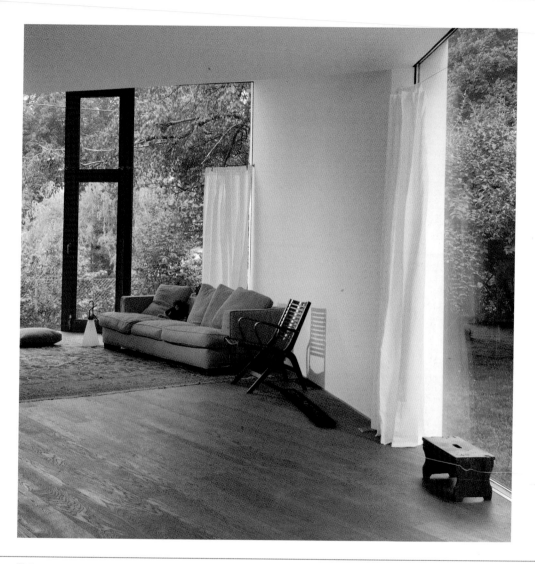

Its geometrical and irregular shape makes the interior space less rigid and gives it a more open look. The simplicity of the finishes, particularly the parquet flooring and white paint, contribute significant harmony to this small space.

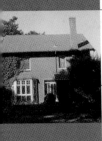

Cedarvale House

Taylor Smyth Architects

Photos © Kerun Ip, Taylor Smyth Architects

◼ Toronto, Canada

This renovation and expansion project of a home built in 1930 and located south of Toronto is an exemplary exercise in how to transform, extend, and modernize traditional residential architecture.

Instead of demolishing the original volume, the architects chose to conserve the exterior, while the interior was fully replaced, with the single exception of the beautiful handcrafted stairway that was carefully restored to create a connection between past and present. The brick exterior was conserved so the house would continue to be integrated in its urban environment and the pitched attic roof eliminated to enable an extension at the top.

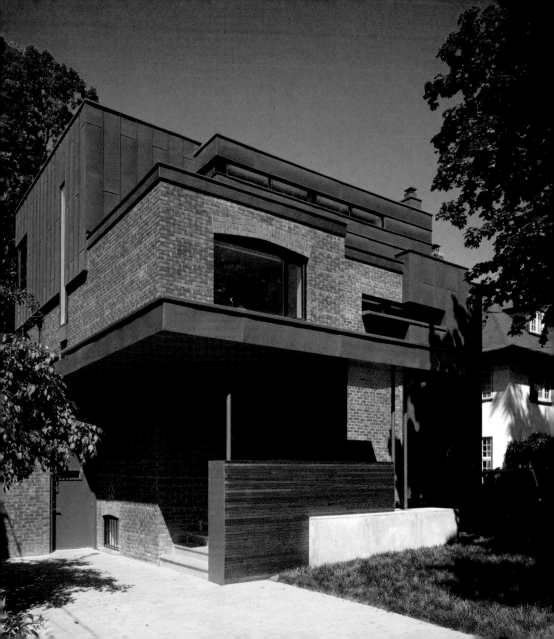

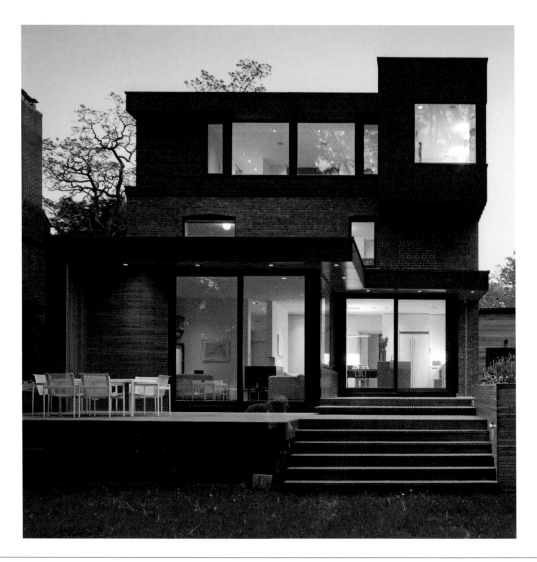

The house, like an architectural palimpsest, reflects how building styles have evolved and demonstrates that the preservation of an urban fabric can form part of a profound transformation project.

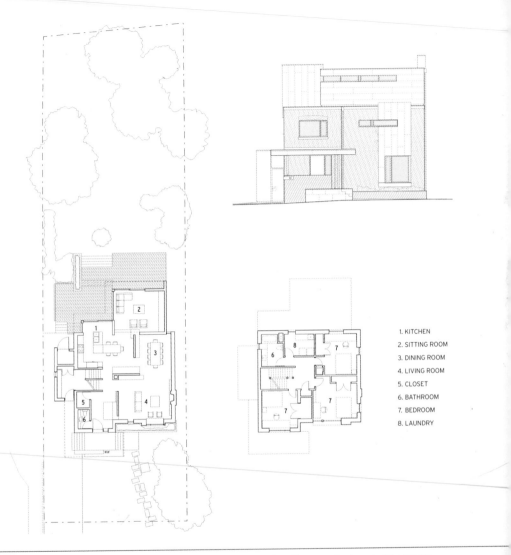

1. KITCHEN
2. SITTING ROOM
3. DINING ROOM
4. LIVING ROOM
5. CLOSET
6. BATHROOM
7. BEDROOM
8. LAUNDRY

Floor plans and south elevation. The first and the second floor plan show the open-plan layout of the spaces.

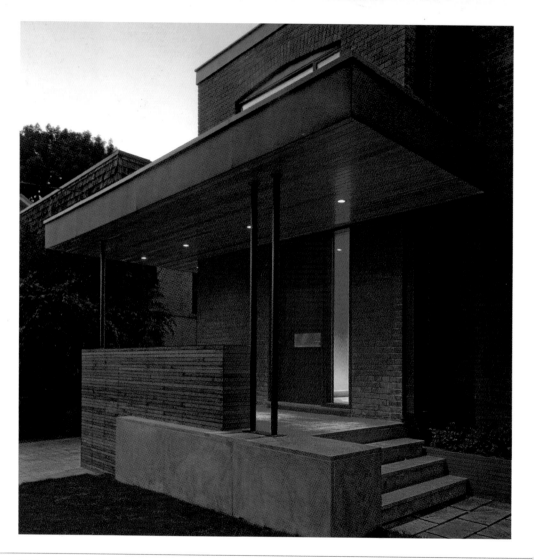

The entrance has been redesigned so that visitors notice how modern the new house is as soon as they cross the threshold.

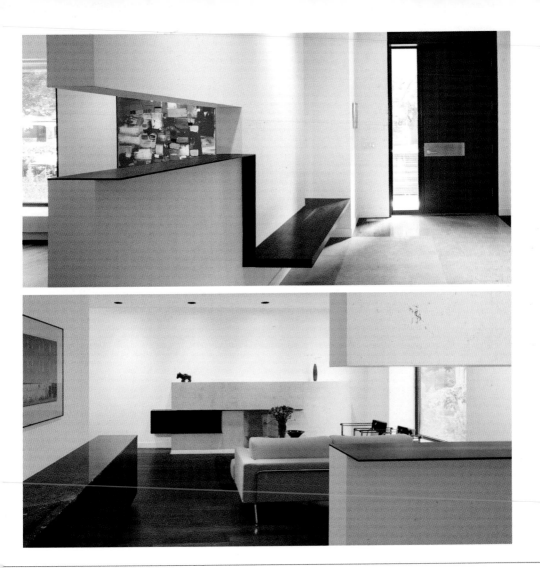

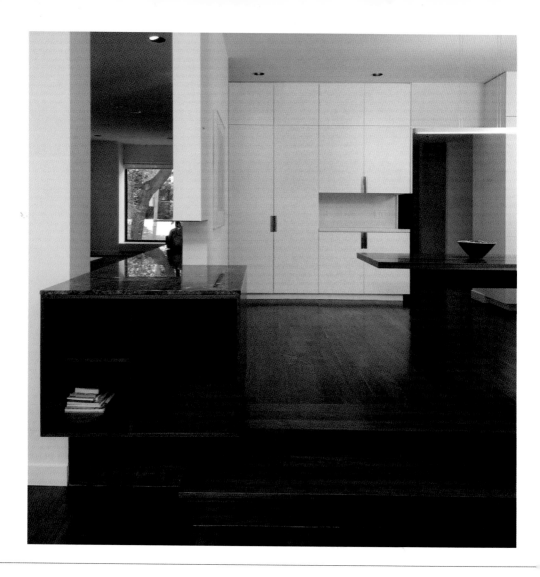

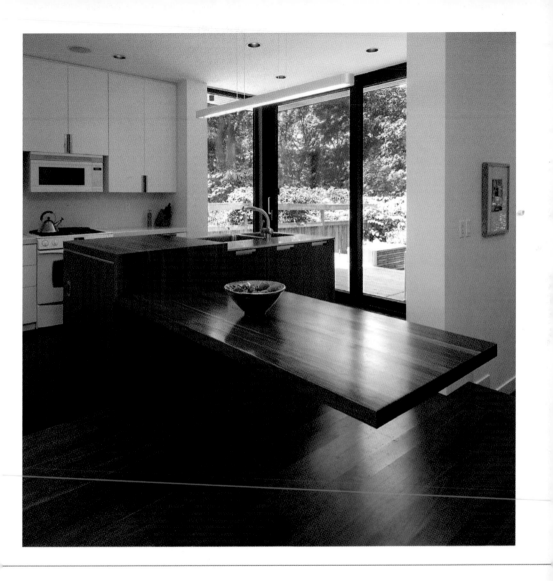

Ocean Beach Residence

Aidlin Darling Design

Photos © Sharon Risedorph

■ San Francisco

A three-story property was built in a cypress forest at a distance of 9 feet (3 m) from an existing house. In the old volume, the only modification was to open one side of the house, at the height of the second story, to install a translucent glass bridge that would connect the two structures. This gave the master bedroom a direct visual connection with the children's rooms.

The new building, with a metal covering at the ends, offers a greater contrast with the natural environment. Inside, following the same design patterns that characterize the old house, the architects opted for open-plan spaces, boosting the dialogue with the trees and sea.

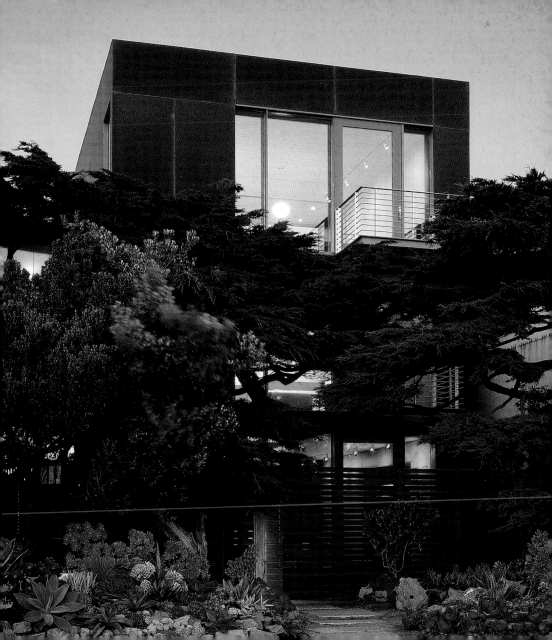

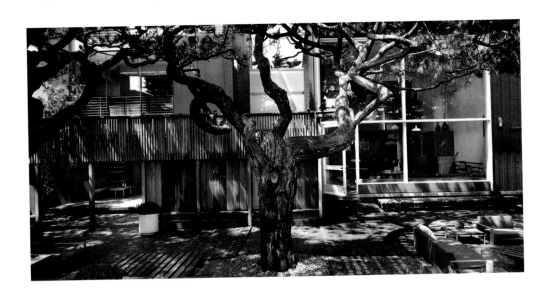

Cross section. The cross-sectional view of the new block makes it possible to see how the interior distribution is very simple and rational.

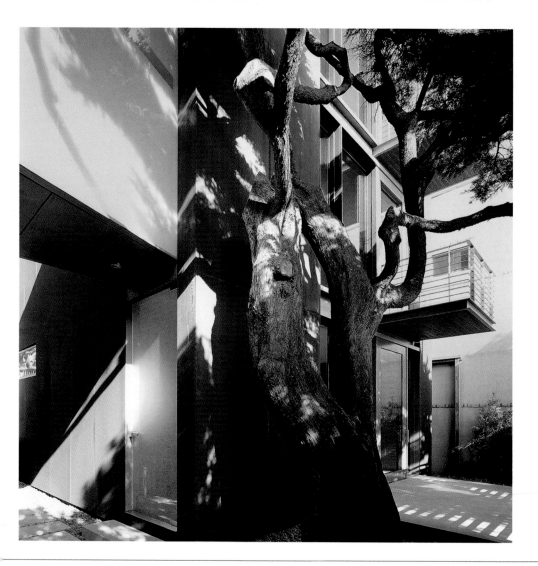

The bridge that joins the original home with the new structure, located at one end of the second story, is completely built in opaque glass.

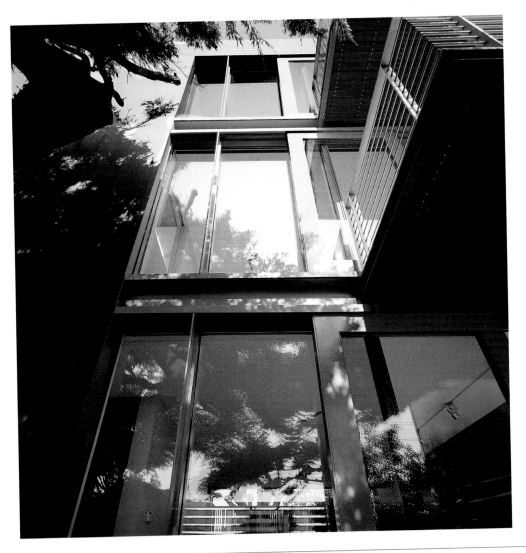

The building is partially hidden by the trees in order to not spoil the natural environment and offers the inhabitants enough privacy without denying them the stupendous sea views.

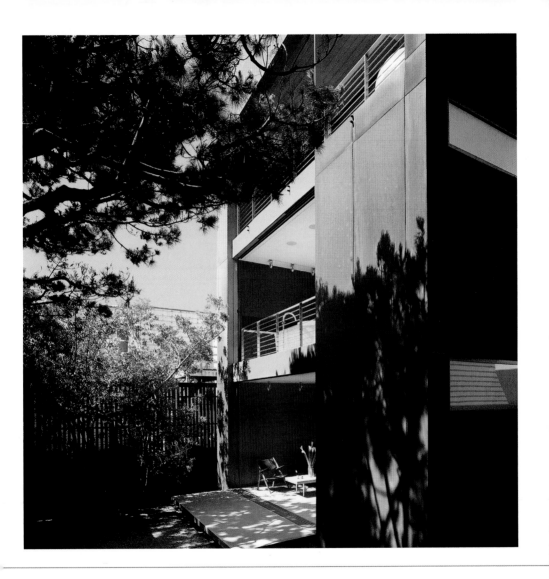

The architects knew how to integrate the two volumes perfectly, both in terms of shape and proportion as well as materials.

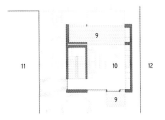

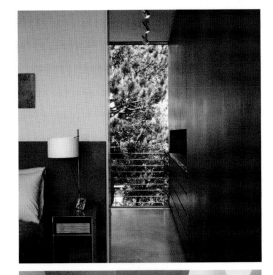

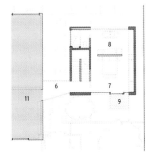

1. FRONT GARDEN
2. GARDEN
3. RUMPUS ROOM
4. BATHROOM
5. METER AREA
6. BRIDGE
7. MASTER BEDROOM
8. MAIN BATHROOM
9. DECK
10. SOLARIUM
11. EXISTING PROPERTY
12. ADJACENT PROPERTY

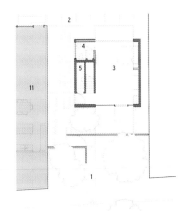

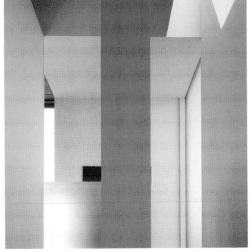

■ Floor plans of the three levels.

The Dairy House

SCDLP Architects

Photos © Charlotte Skene Catling

■ Somerset, United Kingdom

This project consisted of transforming an old dairy building into a single-family residence. To that end, the main work involved reconfiguring the spatial distribution of the floor plan with the aim of building five bedrooms with three bathrooms and a small swimming pool. The architects further supplemented the project by restoring the original elements of greatest value.

The main challenge was to complement the existing structures without affecting the exterior aspect. The use of local materials such as oak and stone, recovered from the area during the excavation and used with a new aesthetic treatment, was paramount in the new work. The partial transparency achieved from the superimposition of the wooden boards is spectacular and becomes the identity mark of the project.

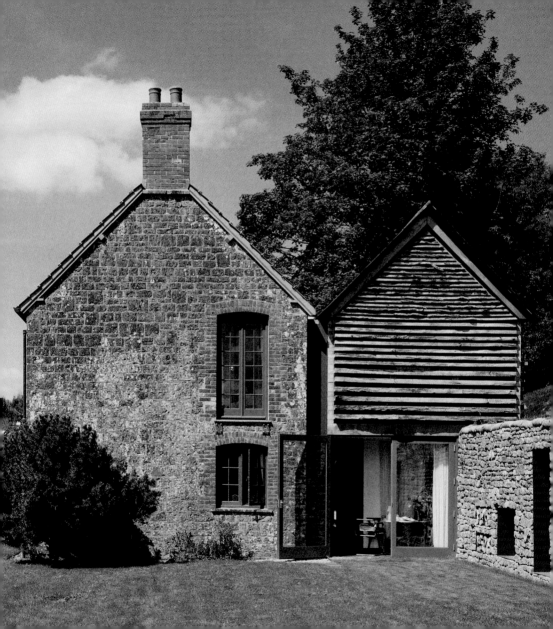

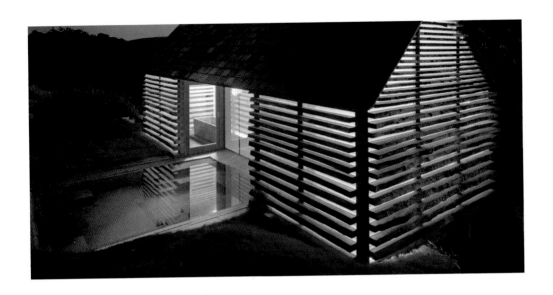

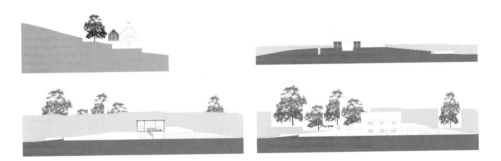

Elevations. The building is developed on an axial basis made up of the retaining wall that supports the S-shaped floor plan.

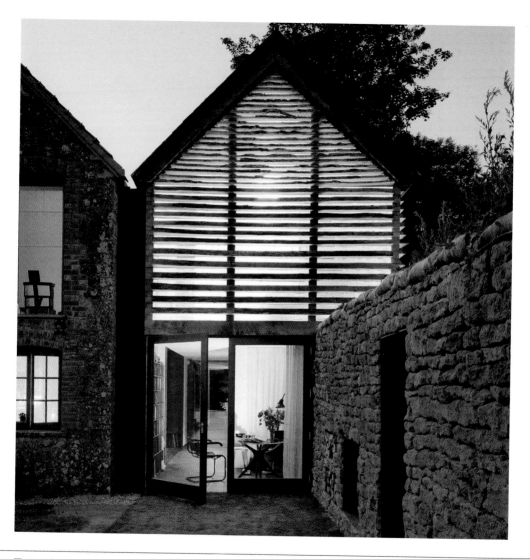

Seen from the outside, the combination of the crossed beams and laminated glass walls generates a mysterious light.

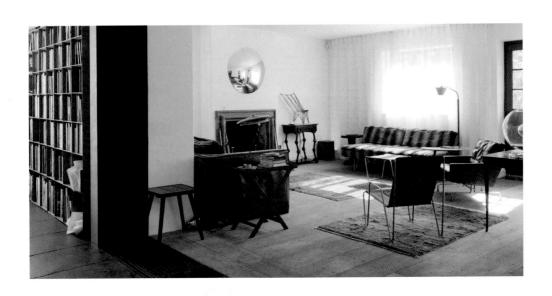

Floor plans. On one side is the old dairy and on the other, the new volume built as an extension of the former one and which makes the most of the difference in the terrain. It was assembled on the wall to enable the swimming pool to be put in.

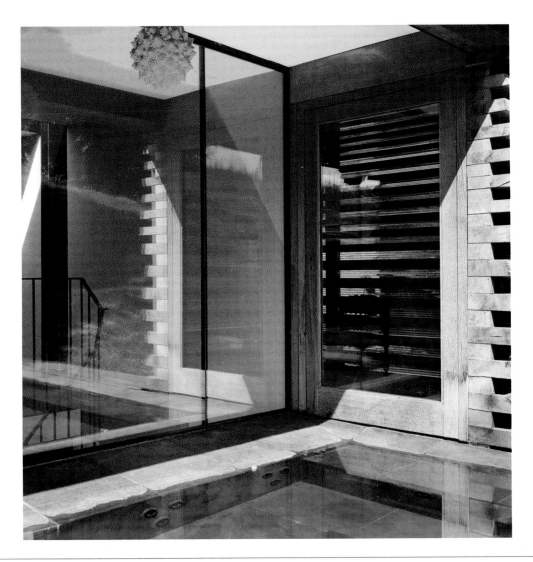

The doors—more modern and stylized than the rest of the façade—provide a contrast between old and new. The intervention seems to be a natural extension of the existing structure.

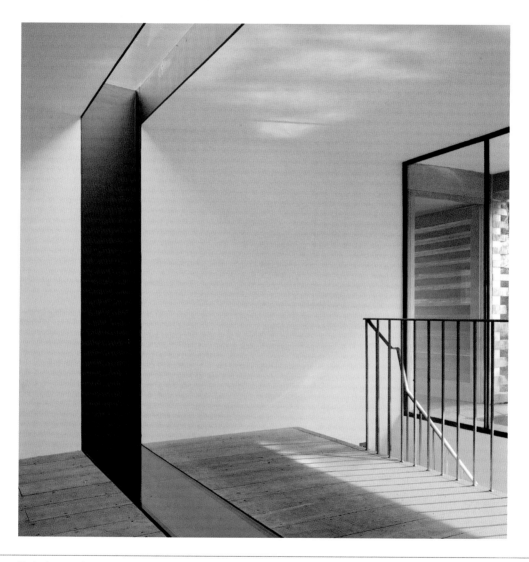

A mirror snakes around the upper floor of the building like the course of a river. At dawn, the glass acts as a prism which tints the floors and walls green and blue.

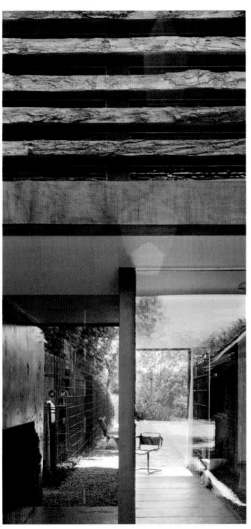
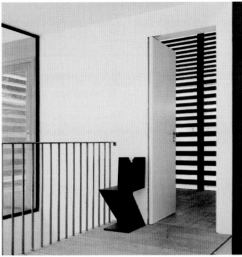
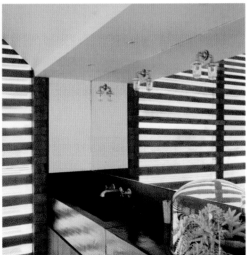

Wohlfahrt-Leymann Residence

Meixner Schlüeter Wendt Architekten

Photos © Christoph Kraneburg

■ Frankfurt, Germany

The Wohlfahrt-Laymann residence is located in a Frankfurt suburb. The owners wanted more living space and at first considered knocking the home down and replacing it with another, larger one. Following an exhaustive analysis, the architects assessed the quality of the existing building, which dates from 1930 and boasts a number of charming features, and decided to use it as the starting point for a comprehensive remodeling job.

The project for the transformation of the property was based on two very clear premises: to expand the useable space and optimize the existing construction. To that end, the architects came up with an extremely original solution: they built a new structure which covers the house like an exoskeleton, enabling them to generate new interior spaces.

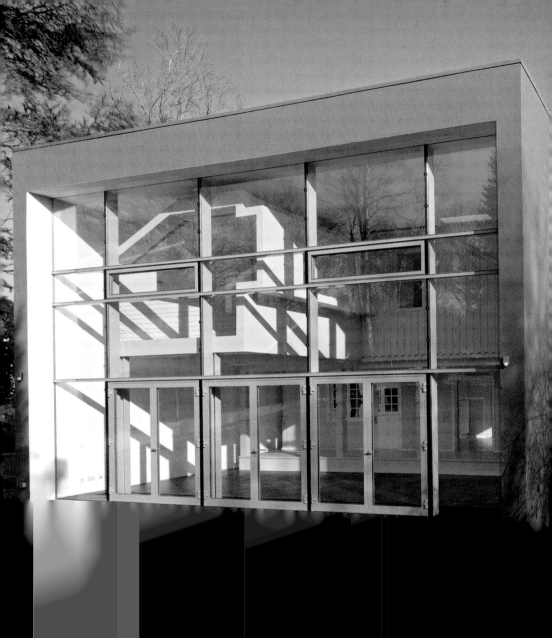

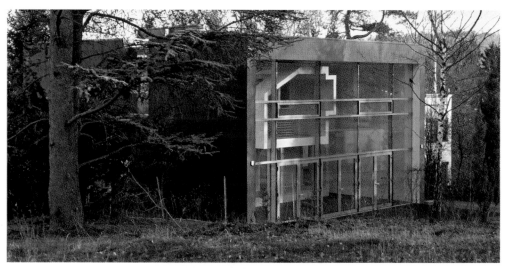

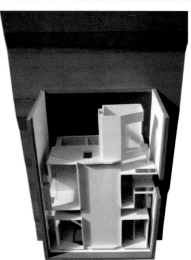

Rendering. The architects were even able to adapt the new windows to the existing openings, helping to cut costs.

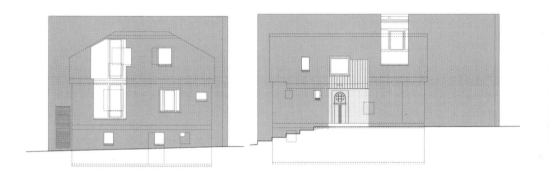

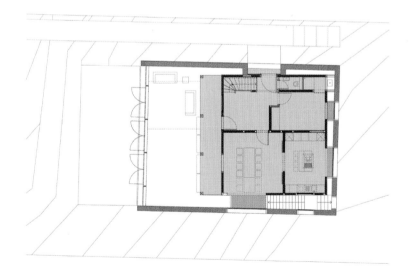

Elevations and floor plan. The rational distribution of the home contrasts with the new spaces created during the expansion works.

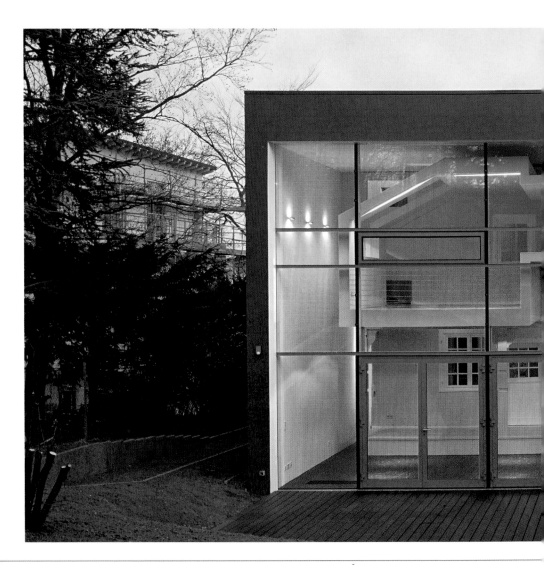

Following the revamp, a surrounding structure in the form of an exoskeleton allows the interior spaces to make the most of the entry of daylight through the façade.

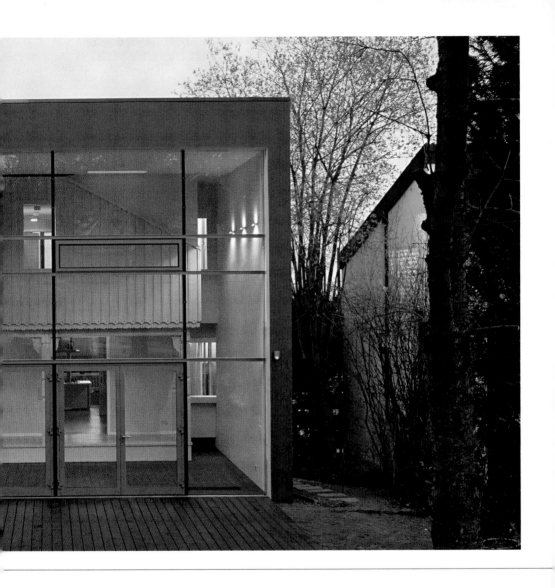

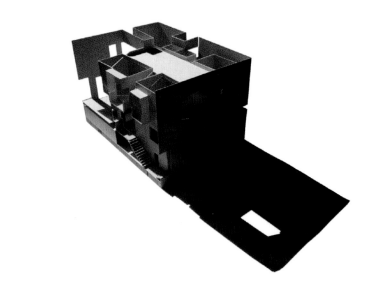

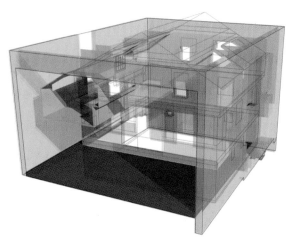

■ Renderings. The original entrance was respected in the north façade and the space developed in one direction.

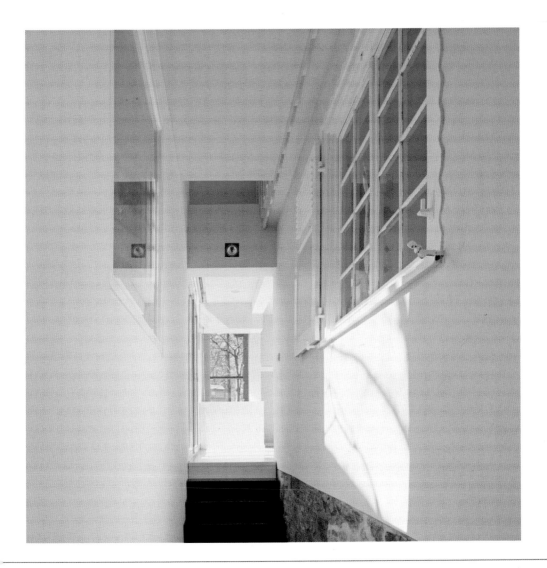

■ This traditional rural house has become the cosmopolitan suburban dream. Inside, the original roof was eliminated and rooms built upstairs.

Rustic Canyon Residence

Griffin Enright Architects

Photos © Art Gray

■ Los Angeles

The revamp of this residence represented a change to the regular conventions of single-family home design. A country house with a very conventional appearance was transformed into an open and flexible residence, fully interrelated with its environment.

The renovation was based on adapting a common space under a zigzag roof, inspired by the slope of the terrain. This integrates the property perfectly with the landscape and blurs the borders between inside and out.

A careful selection of wood for the coverings and the profusion of indirect points of light boost the warm and tranquil feel of these interiors, very much in keeping with the rural setting that surrounds them. The contrast between these solutions and certain more modern designs, such as the fireplace and kitchen, is one of the successes of the project.

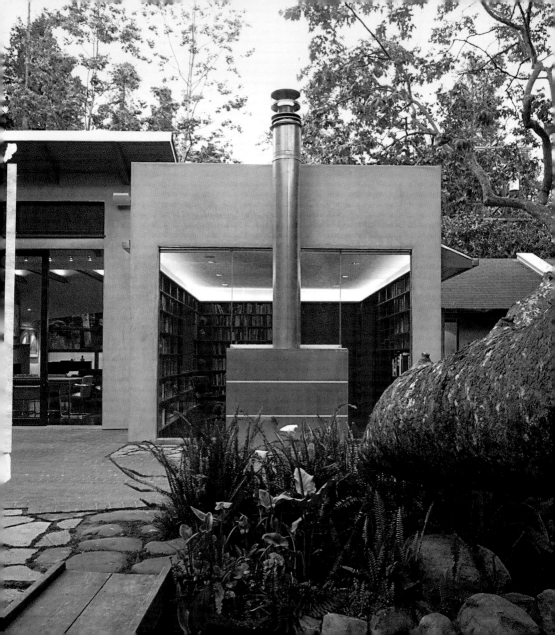

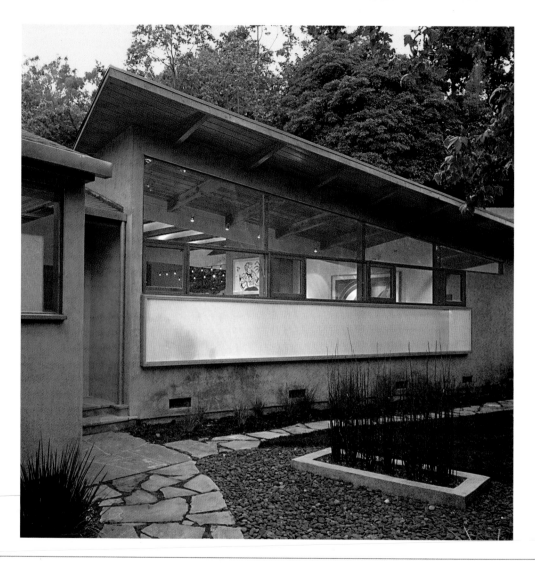

The window is composed of three horizontal modules; the top one matches the pitch of the roof and plays with the slope and volumes to define the entrance to the home.

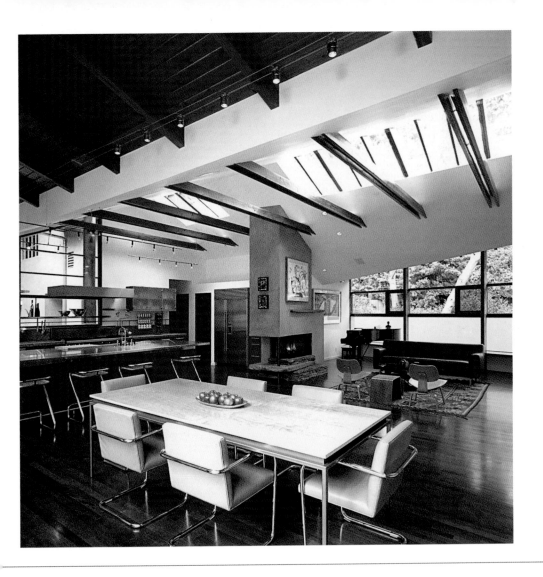

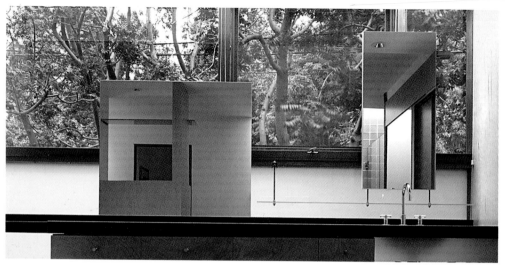

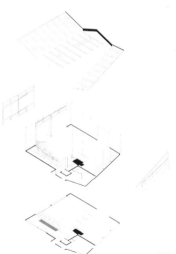

■ Exploded view. The roof composed of planes with different inclinations is unified by the beams, which also provide a more favorable scale. The modular structure of the design can also be seen.

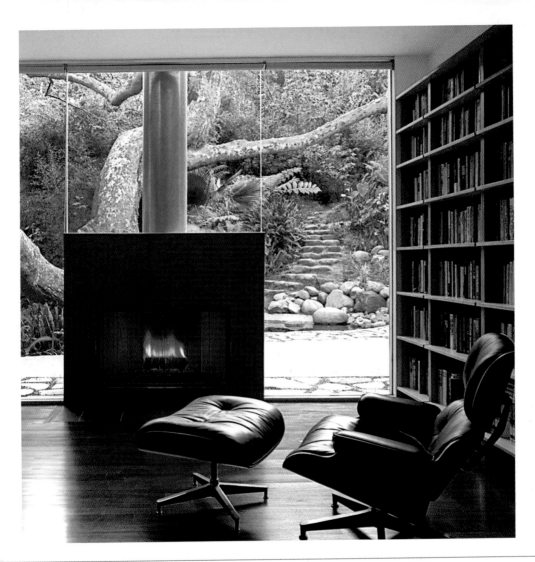

■ The fireplace connects the living room, dining room, and kitchen, defining an axis for the main and back doors. The three public rooms create a unique space that facilitates communication and circulation.

Residence for the Irish Ambassador

Don Murphy/VMX Architects

Photos © Joe Schmelzer

■ Wassenaar, The Netherlands

The reform work done on the Irish ambassador's residence in the Netherlands included an extension for a driveway and the renovation of the house. A professional kitchen was installed in the extension, along with an apartment for the chef. Given the lack of space, this apartment was built half a level below the kitchen, perforating part of the terrain to allow light in. At the top, the kitchen work area is used as a "light box" for the apartment.

The side façade of the apartment is covered in pieces of rectangular glass which alternate different degrees of opacity, making the house seem to merge and almost disappear into the landscape.

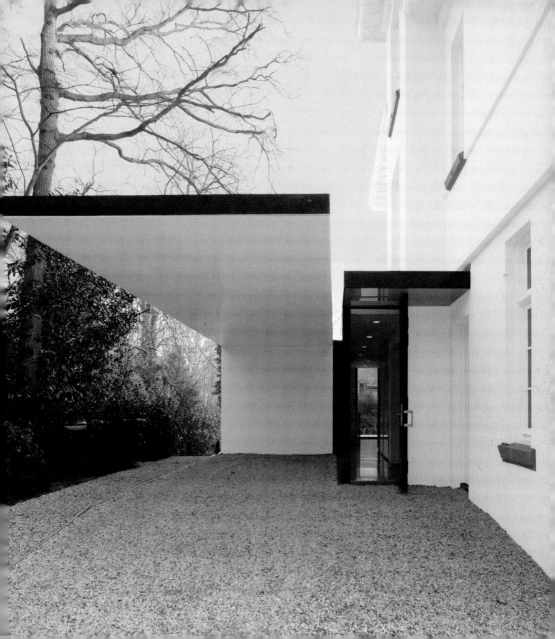

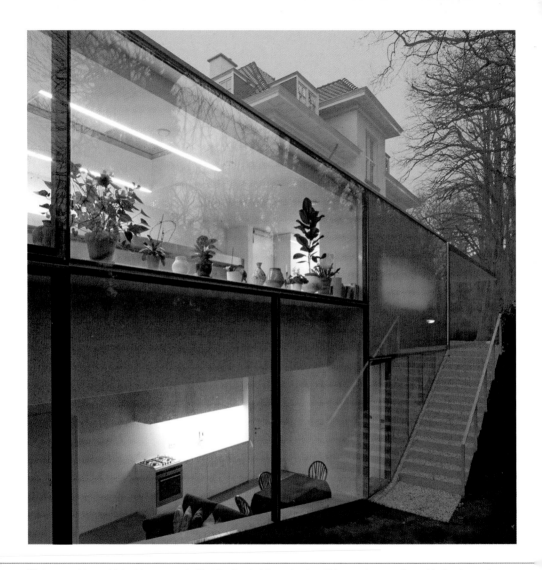

A covered two-vehicle driveway was built at the front of the extension. This space was configured in the shape of an "L," leaving 10 feet (3 m) in height and a 33 feet (10 m) projection.

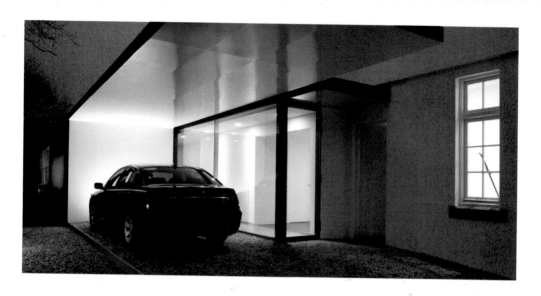

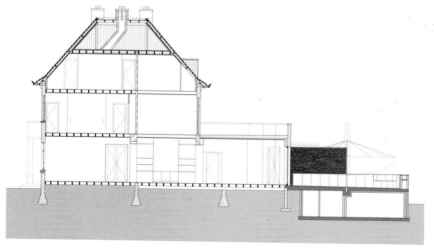

Section. Complete section view of the home, showing the work done to build the basement and boost the home's useable space.

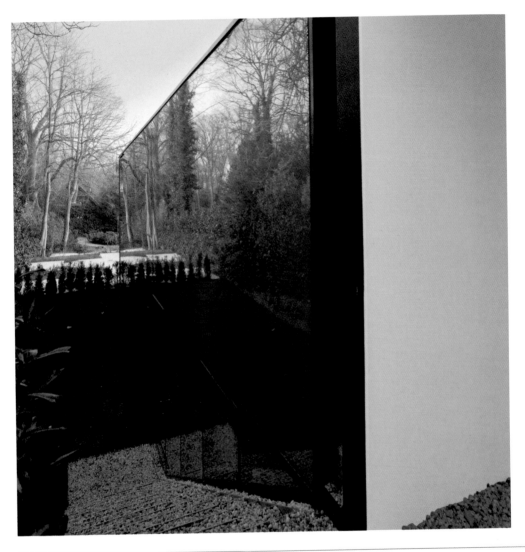

The glass side façade allows the house to merge with the landscape. The glass corridor is a delicate and translucent space which greets visitors.

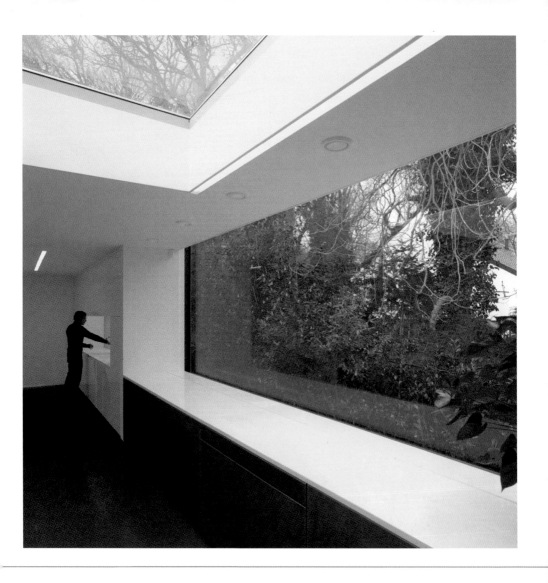

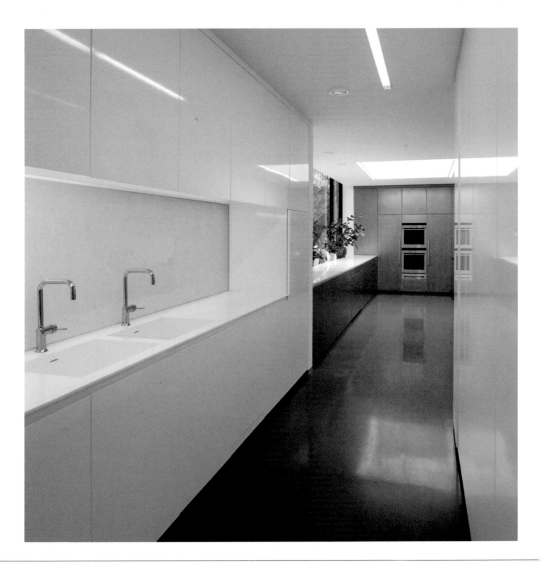

The kitchen had to be a large, bright space, as the ambassador often receives visitors. Materials with a smooth and reflective finish were used in the kitchen to facilitate cleaning and maintenance.

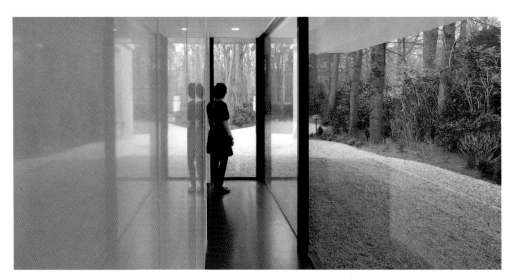

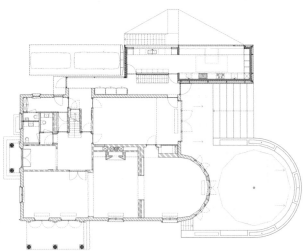

Ground floor plan. On the ground floor, the main spaces comprise the kitchen, dining room, and living room, the latter of which has a large deck for enjoying the garden.

Wooden Weekend Retreat

Hût Architecture

Photos © Matt Chisnall

■ East Sussex, United Kingdom

A 1950s bungalow set in a beautiful position on the south coast of England has been rebuilt to create a modern and sustainable home.

The whole of the building was insulated and completely covered with Siberian larch. The wood was made weather-resistant but kept its rustic look. New double doors were put in at the entrance, as well as new windows and skylights, opening up the passage of sunlight. Simple materials like rough-hewn wood, polished concrete, and galvanized steel are used inside to create a rustic and simple ambiance in harmony with the surrounding forest.

136

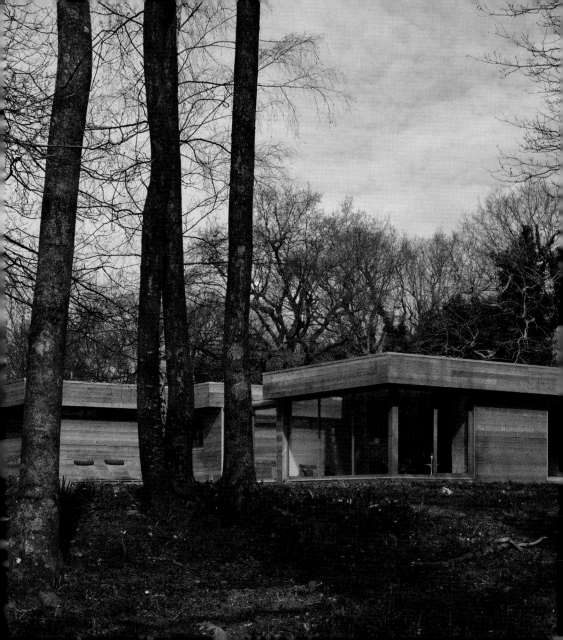

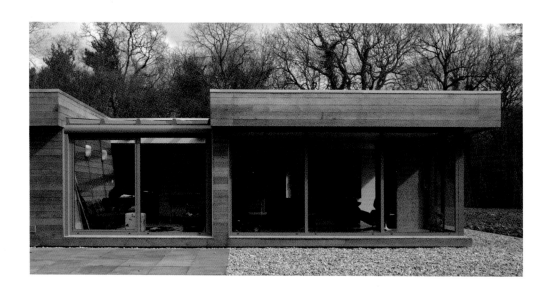

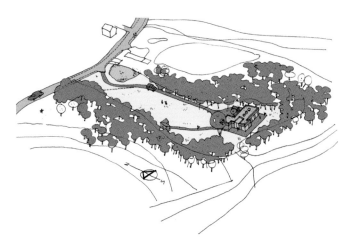

Site plan. The privileged location, set far back from the main roads, makes this house a perfect place to relax.

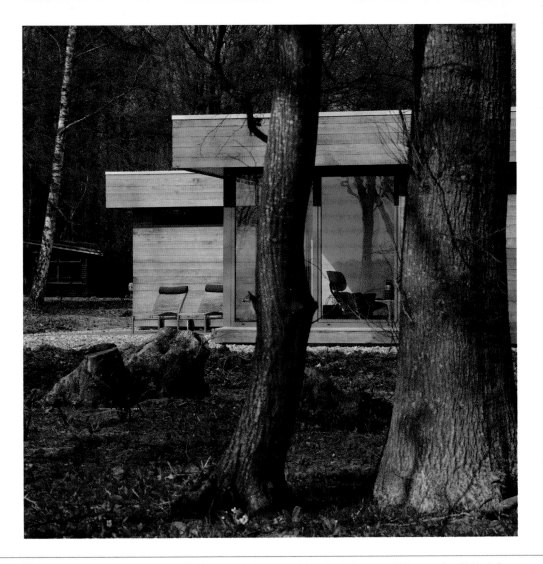

Like the original property, the rehabilitation respects the property's horizontal nature, which contrasts with the tall trees that surround it.

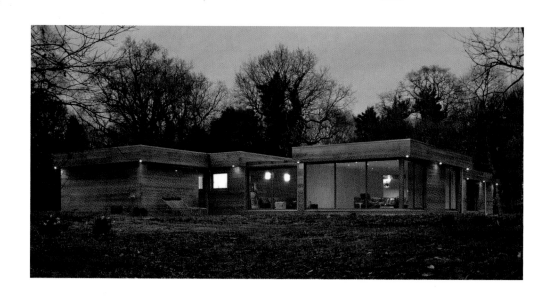

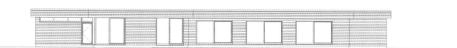

Elevation. In the social areas, such as the living room, the architects opted for large glassed-in areas to make the most of the views.

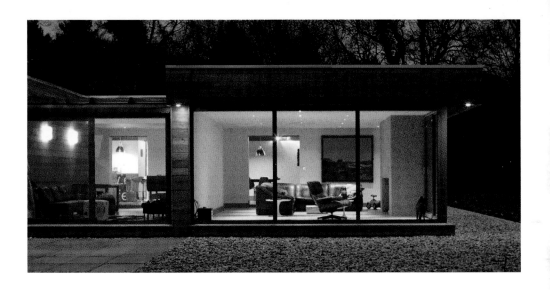

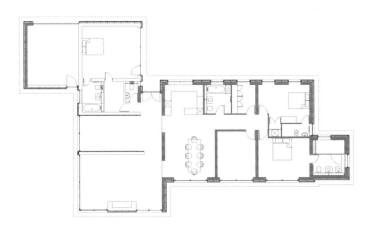

Floor plan. It shows the distribution of the house; the master bedroom and living room have the best views, although the other rooms also enjoy ventilation and natural light.

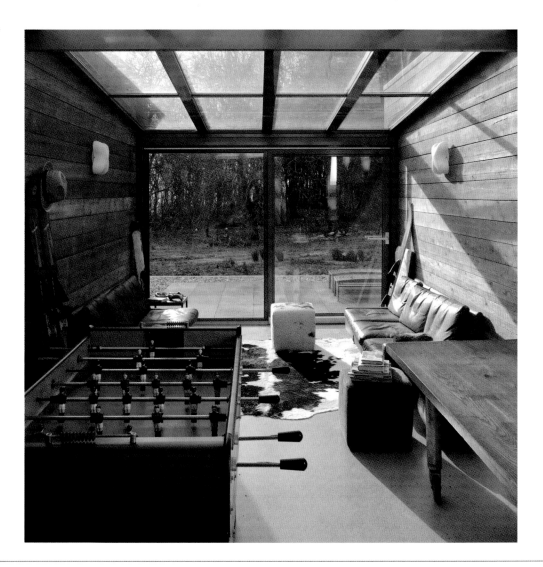

The wooden beams, treated to make them longer-lasting, contrast with the rest of the furniture in a space where simplicity is key.

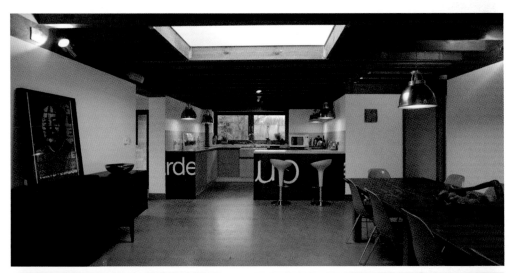

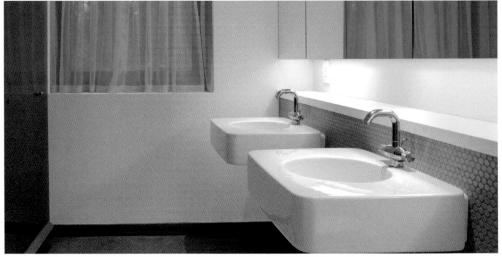

Library Addition

KJD Architects

Photos © Joe Schmelzer

■ Los Angeles

This private library, which can hold 15,000 books, is an extension of a 1925 Tudor-style building. The client is a booklover whose continually growing collection had become too big. The project establishes a strong dialogue between the residence, landscape, swimming pool, and new library volume.

The zinc covering on the outside runs around the three exposed sides of the volume and roof. The client wanted to project videos here, as if it was a small home cinema in the garden. To make this possible, the north façade was given the ideal proportions for panoramic viewing.

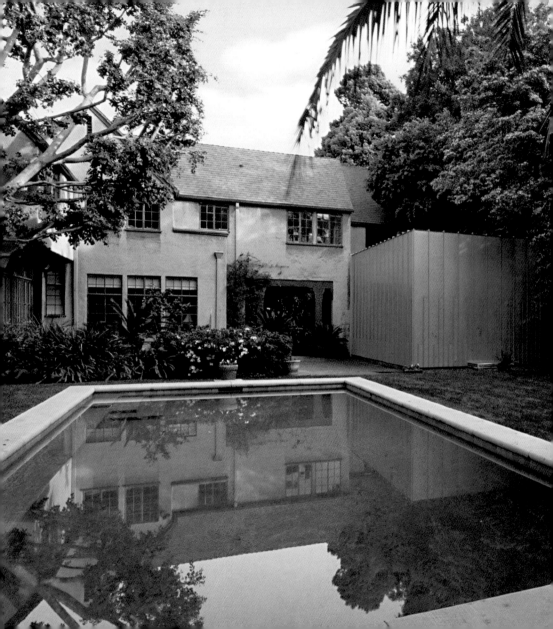

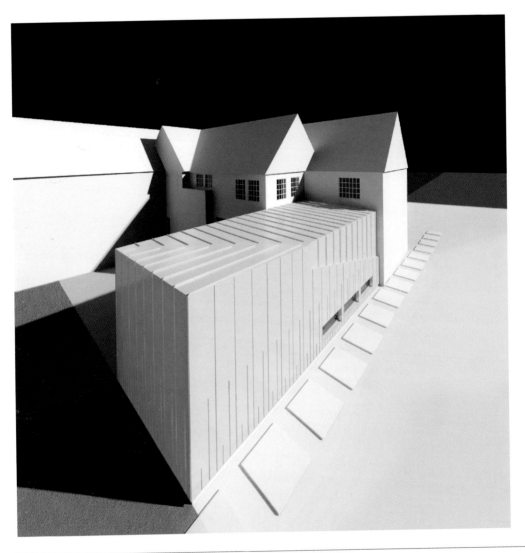

■ Rendering. Previous study of the volume to be constructed, taking into account the materials, the pitch of the roof to evacuate rainwater, and the volume gained inside.

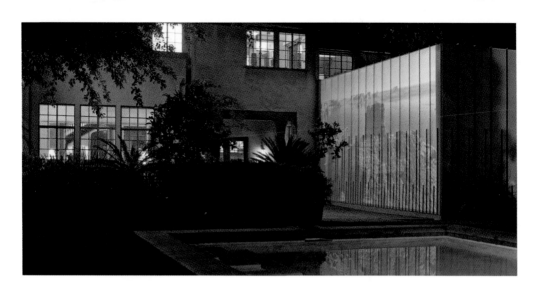

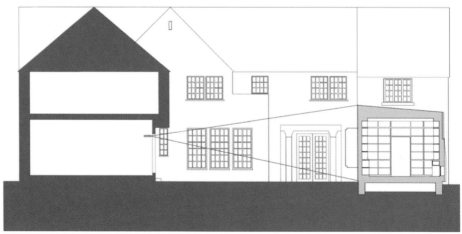

Cross section. It shows the location of the projector, decided on after carefully studying the distances and projection angle.

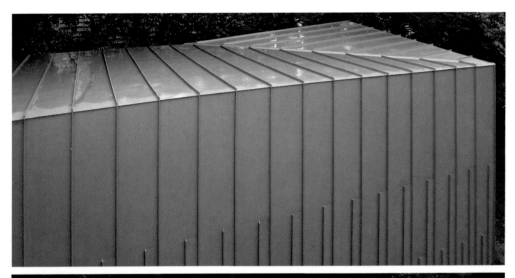

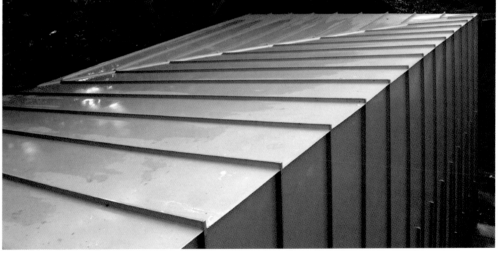

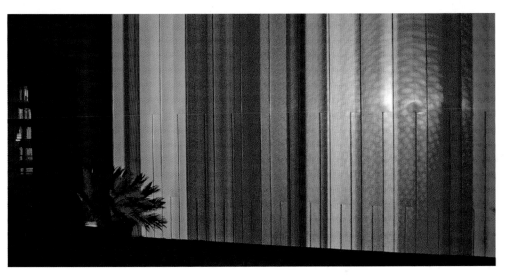

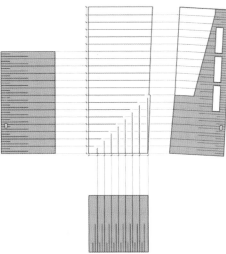

Exploded view of the zinc covering. The unique irregularities are produced on the south façade which looks onto a neighboring property.

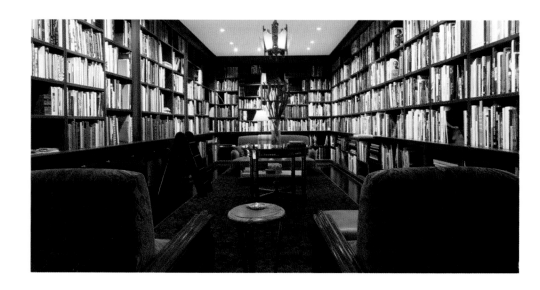

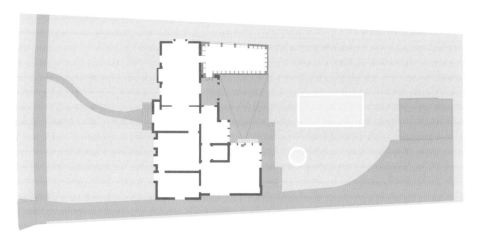

Site plan. The plan shows the proportions of the library with respect to the house. With the expansion, the floor acquired a symmetry it had previously lacked.

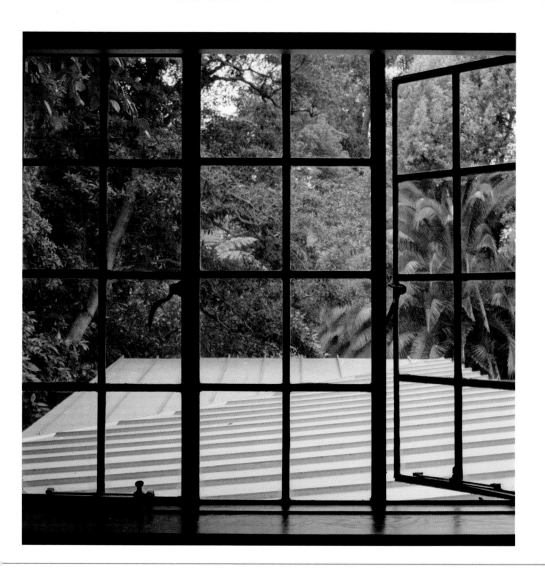

70s House Renovation

Coast Gbr

Photos © David Franck

■ Weinstadt-Beutelsbach, Germany

With the alterations, the owners of this 1970s property—a young family that shares the home with their grandfather—wanted to make it easier for the elderly gentleman to get around in his wheelchair so he could have a certain degree of independence. They also wanted the attic to be a self-contained unit they could rent out. This meant it had to have an independent entry way.

As well as these transformations, the renovation included a series of environmental measures, such as the installation of solar panels and a rainwater tank system. These actions made it possible to cut the property's energy costs by up to 88 percent.

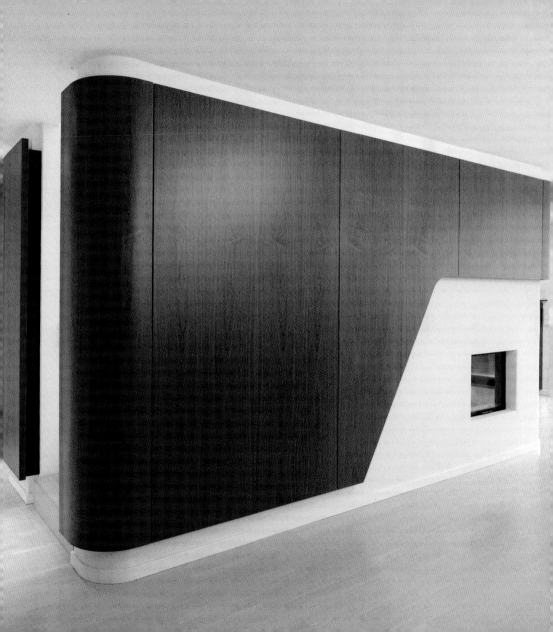

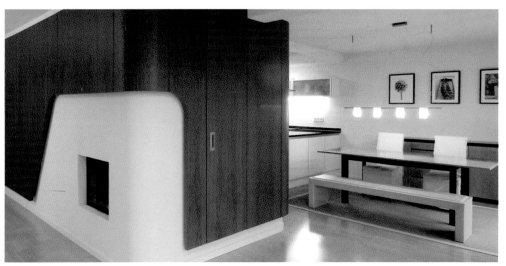

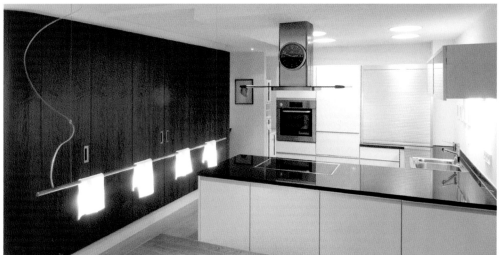

The central module has been strategically positioned to define the various spaces on the floor plan. Its differentiated treatment, using oak-looking plywood, sketches a continuous line that unifies the spaces.

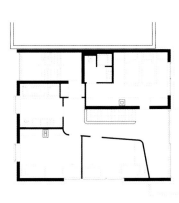

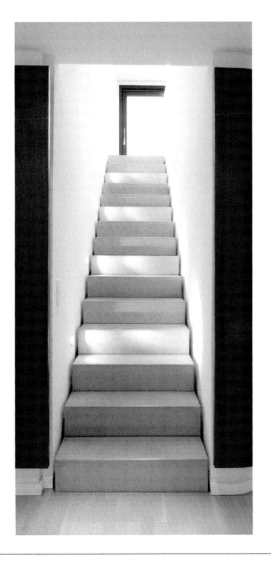

Floor plan. The existing staircase continues to function as an entrance for the inhabitants of the house and will also be used to access the rental property in the attic. The new internal staircase leads to the private rooms on the second floor.

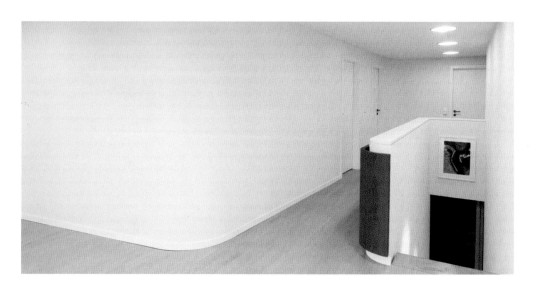

Floor plan. With the reform, the interiors are more fluid. The garden design leads to the main entrance, on the south façade. Another door, with a ramp, was added at the ground floor level.

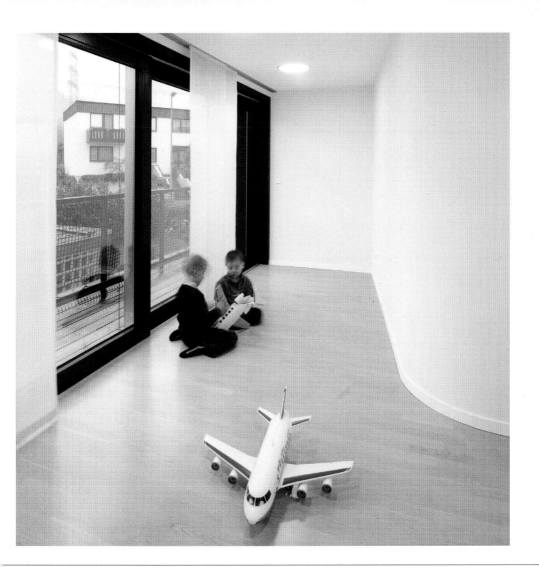

■ On the top floor, the walls contribute to the visual continuity. Circulation is determined by large circular soffits in the middle of the ceiling. One of the bedrooms was turned into a playroom for the children.

■ cityside

29th Street Penthouse

Rogers Marvel Architects

Photos © Paul Warchol

■ New York City

This penthouse apartment was designed for a European artist and collector. The balcony affords magnificent views over the city and some of its most emblematic buildings, such as the Empire State Building.

The spaces were organized in a circle around the central nucleus of the staircase, from which the path around the different public and private rooms is established. All the areas are fitted with large windows to favor a direct relation with the exterior.

The first floor is reached via a floating staircase built in steel and covered in wood. The work on this floor included the balcony and an open-plan recreational area that boasts stunning views. All the wood in the apartment was recovered from a number of fir beams taken from a demolished New York building.

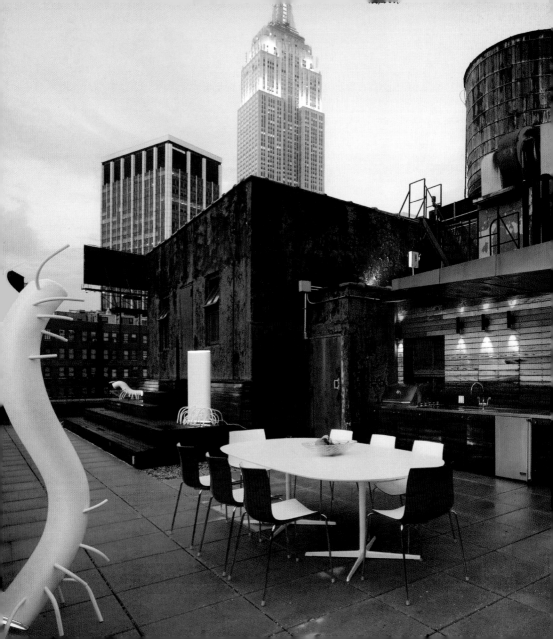

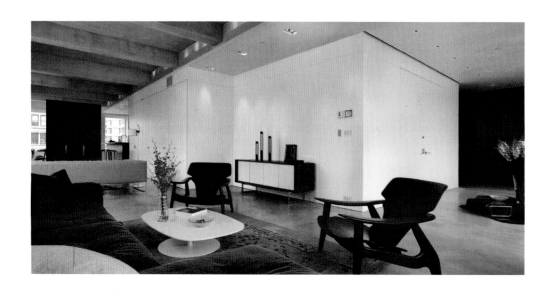

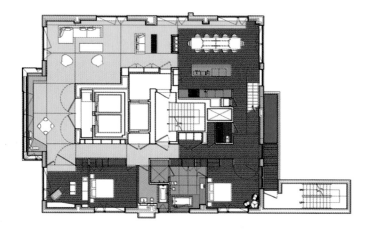

Floor plan. The spaces in this apartment are organized in a clockwise fashion: first come the two living rooms, which connect with the kitchen/dining room, and from there one moves through to the bedrooms.

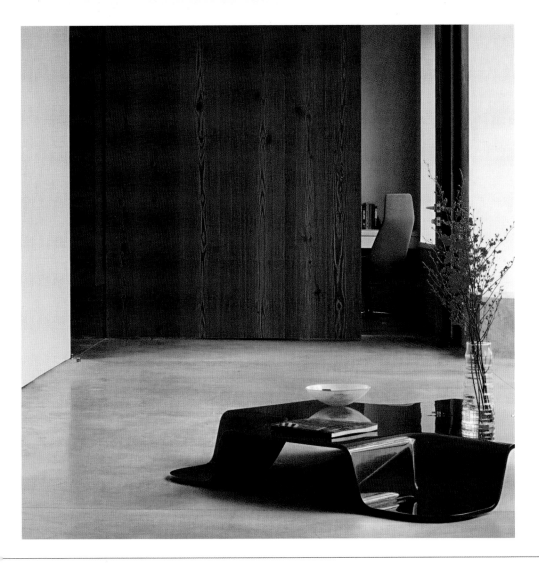

The designer table in the entrance hall welcomes guests. Behind it is a small study, separated from the public zone via recycled-fir sliding doors.

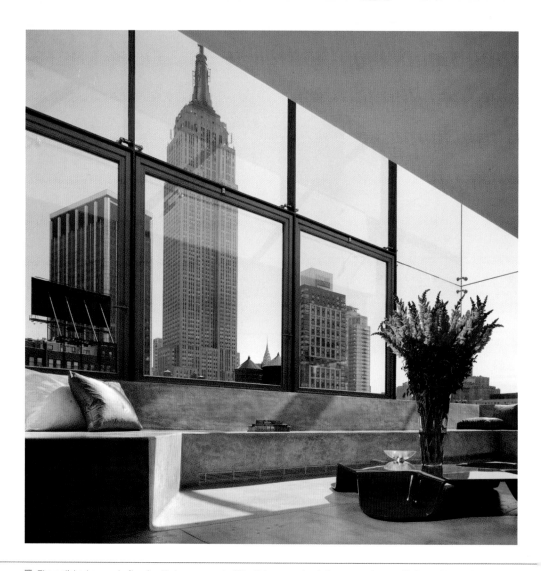

The polished concrete flooring that covers part of the living room leads to a concrete area that provides a place to relax and greet visitors.

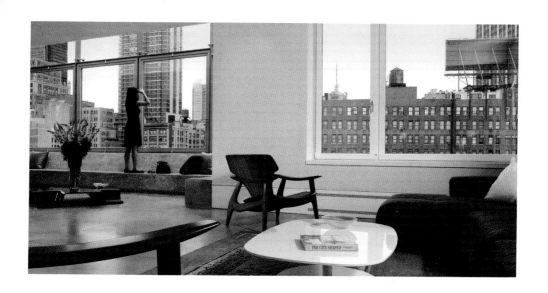

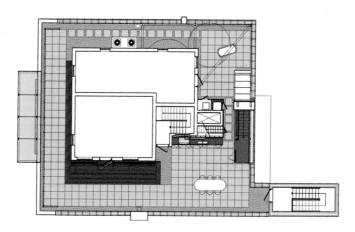

Second floor plan. The balcony is connected to the apartment internally via a floating wooden staircase. It opens onto the outdoors and affords wonderful views across town.

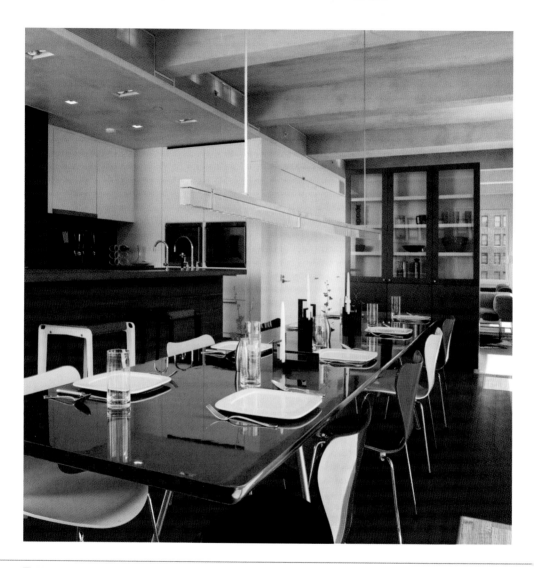

The kitchen boasts a linear layout and combines cheerful colors with cold elements such as the cement in the false ceiling and the white walls. The change of flooring and a steel door visually separate the spaces.

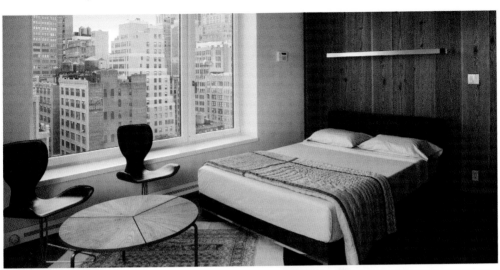

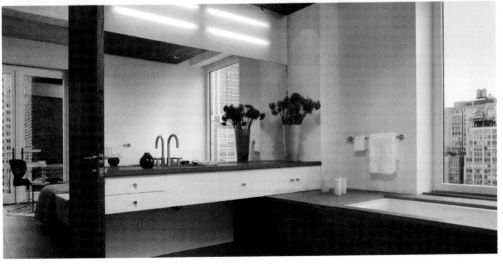

New York Townhouse Renovation

Alexander Gorlin Architects

Photos © Peter Aaron

■ New York City

This restoration is in fact a comprehensive project that includes expansion works and the recovery of a property originally built in 1958.

One of the main interventions consisted of adding a new floor and expanding the façade vertically, always respecting the existing architectural language. The interior was completely remodeled except for the first floor, where the original finishes were maintained. The central staircase was restored and a section added to extend it up to the third floor. Skylights were put in at strategic points to allow daylight to enter the whole of the home.

168

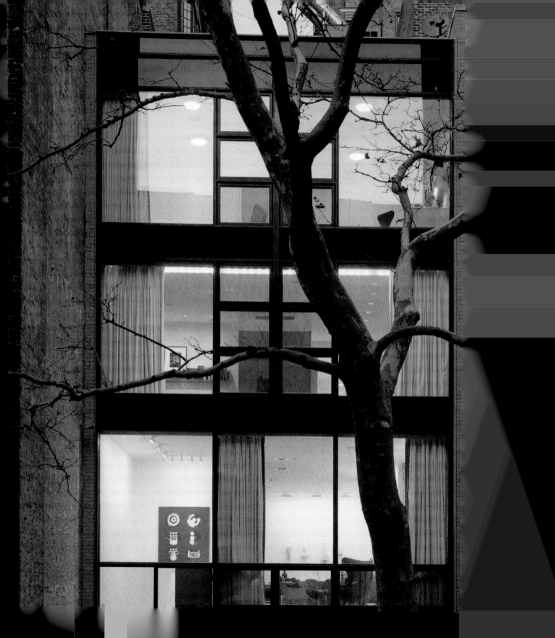

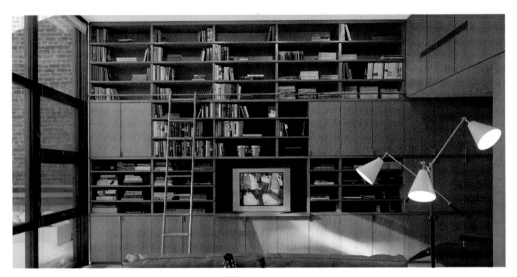

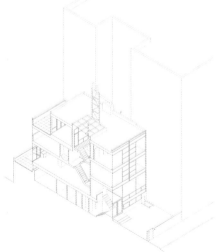

■ Axonometry. This axonometric view of the property shows the play of volumes. The skylights above the staircase offer abundant natural light.

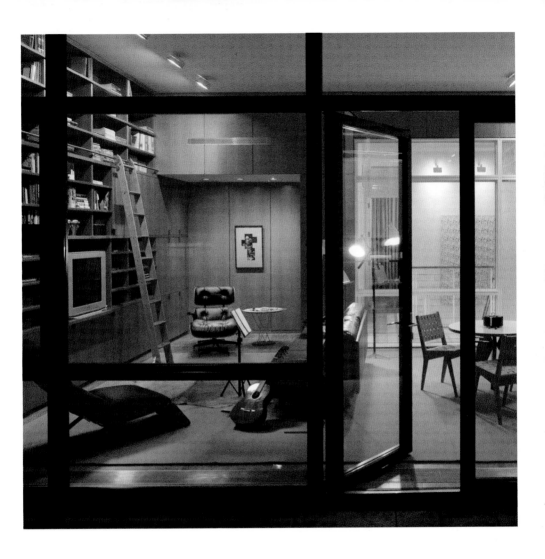

The owners sought a privileged place for their books, so they designed this reading room with an enormous bookshelf that covers one whole wall.

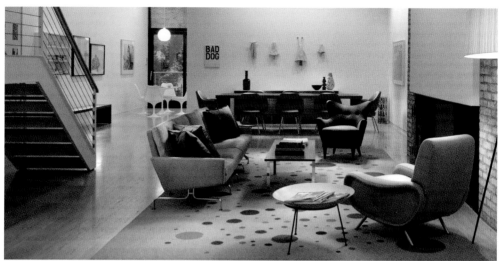

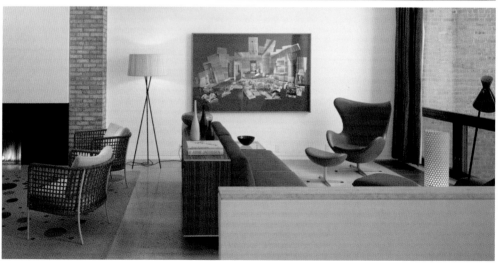

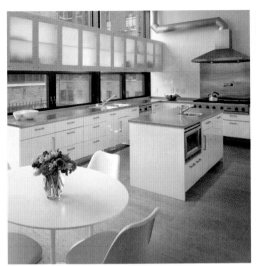
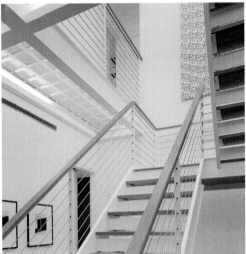

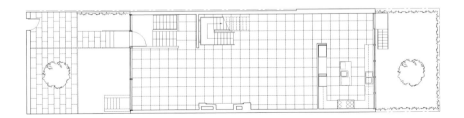

First floor plan. The first floor shows the spaciousness of the completely open-plan area used as the living room.

1900s Villa Transformation

Group8

Photos © David Gagnebin-de-Bons & Benoît Pointet/DGBP

■ Chêne-Bougeries, Switzerland

The aim of the work was to renovate a house from the start of the twentieth-century, located in Chêne-Bougeries, Switzerland. The design proposed making specific use of each space and achieving an important visual change through the use of new colors and light sources. The idea was to establish a complex relationship between the new and old structures, achieving a combination of juxtaposed styles.

With these alterations, the architects sought a new indivisible entity. The spatial sequence is the following: ten rooms and ten different ways of using color in each space. The original construction was preserved as much as possible, with the aim of simply giving it a new, more contemporary, air.

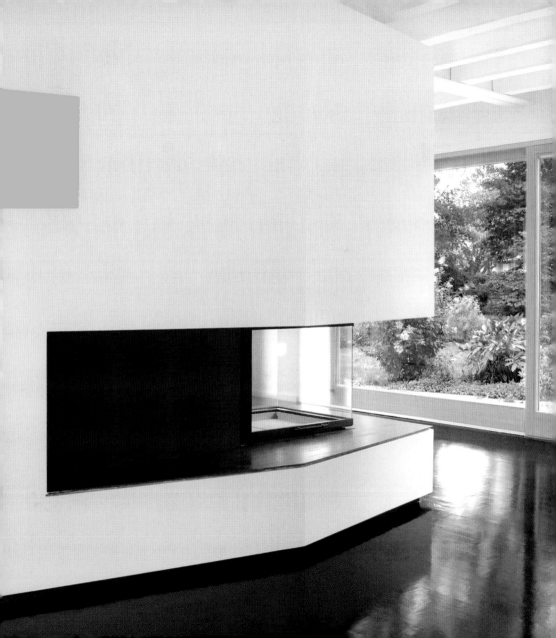

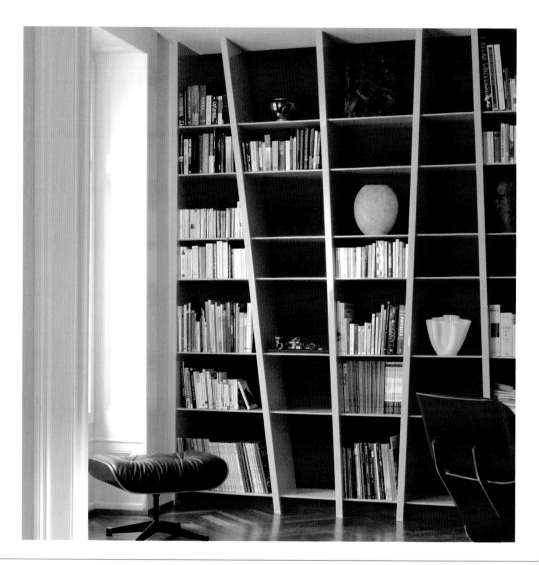

The designers played with contrasts in the library section of the living room: the white designer module stands out against the orange background. The wooden flooring is original to the home.

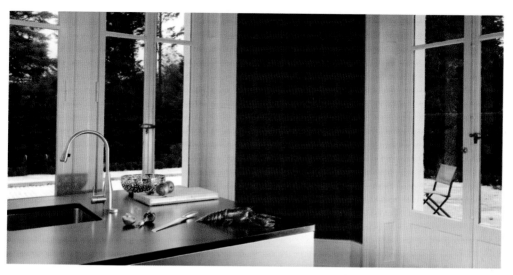

Floor plan. The kitchen, dining room, living room and library are on the ground floor, along with the entrance hall. As the house is a completely isolated building, each room opens onto the garden.

■ The staircase connects the ground floor with the bedrooms and bathrooms. Very bright colors, such as orange and cyan blue, were chosen for these spaces.

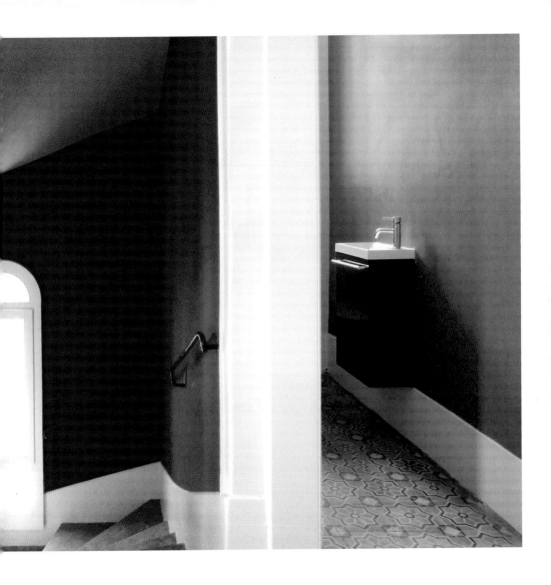

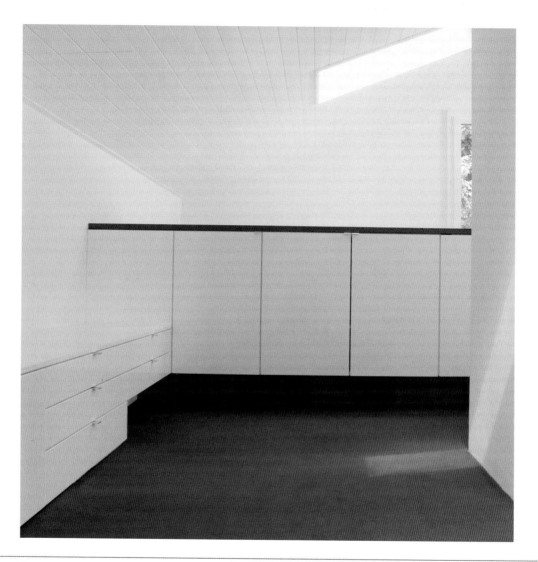

The magenta rug in the main bathroom and dressing room offers a powerful contrast to the white that predominates on the walls, ceiling, and built-in wardrobes.

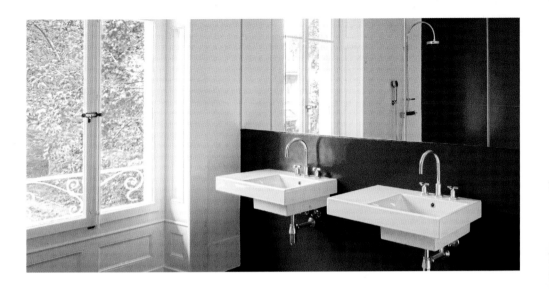

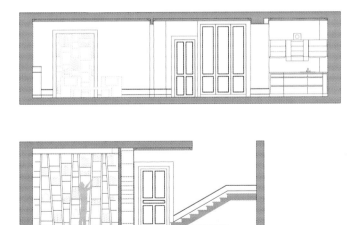

Cross sections. The lower section shows the library, positioned opposite the stairs that lead up to the bedrooms and bathrooms. Above, the dining room and kitchen.

Carmen House

Miguel Arraiz García/Bipolaire Arquitectos

Photos © Juanjo Peret

■ Valencia, Spain

The property, whose structure dates back to 1788, is located in the neighborhood of Carmen, in the Spanish city of Valencia. Its distribution was originally compartmentalized and involved eight rooms in just 950 sq. ft. (88 sq. m).

The main instruction was to create an open space, rescuing the original structure and making the most of the ceiling heights. The architects designed the project in cubic meters, which helped them expand the property to 1,300 sq. ft. (121 sq. m), largely thanks to the creation of a mezzanine level.

Functionally, the house is structured around the central staircase. The kitchen, living room, and bedroom form a single common space, although the bedroom area has maintained its privacy. The construction of the mezzanine level required the fastening of the rear load-bearing wall and central posts. To reduce the loads, a light forging solution was chosen, in the form of a 0.9-inch (2 cm) phenol panel on which the parquet flooring finish was positioned.

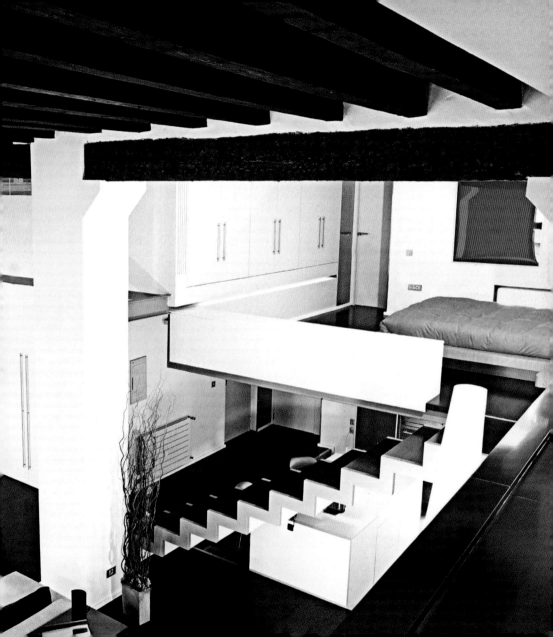

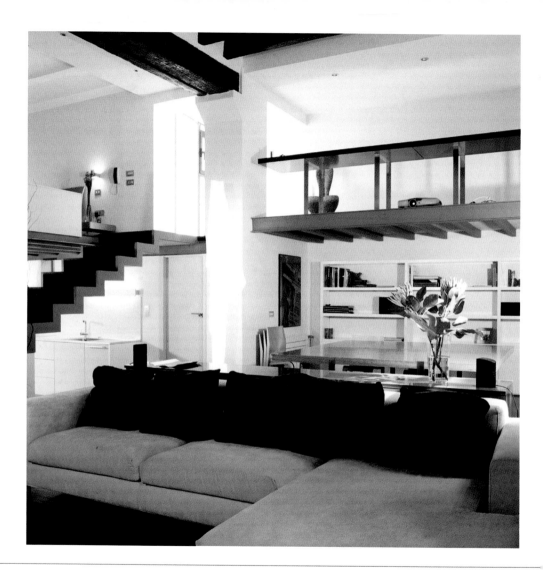

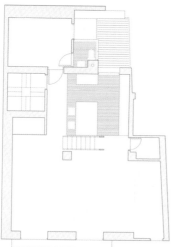
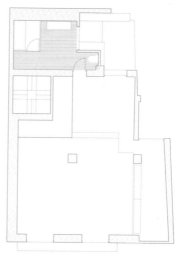

■ Ground floor and mezzanine. Before the work began, the house covered 950 sq. ft. (88 sq. m) and was distributed into eight rooms. The reform work configured a unique, open, and well-lit volume without losing the privacy of each zone.

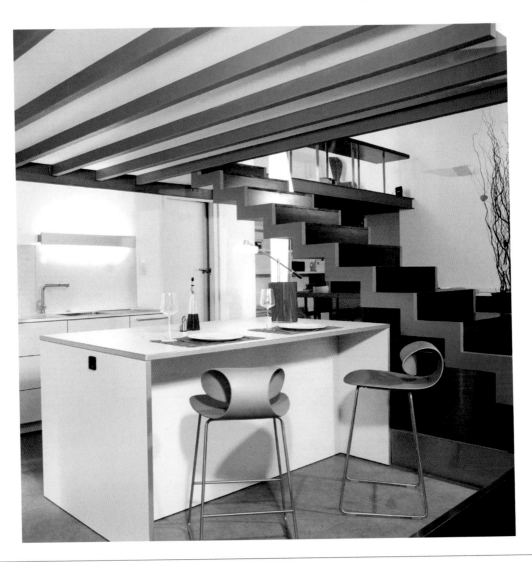

The staircase at one end of the kitchen is the main and most eye-catching part of the home. Designed as a unique piece in wood and steel tubing, it relates the various spaces and diverse functions, giving the home a great deal of dynamism.

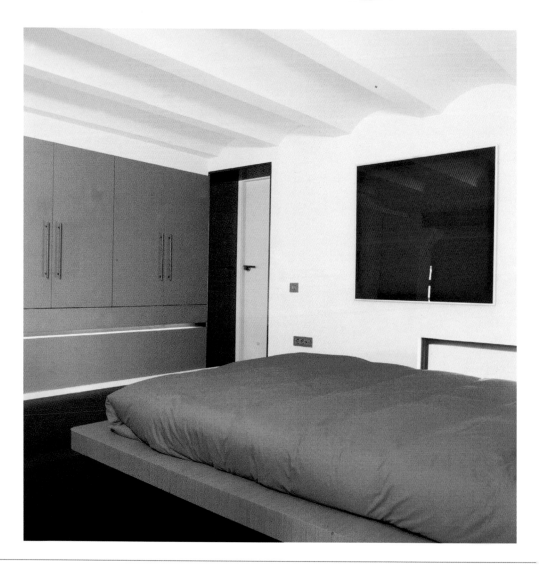

The bedroom and bathroom are located on the upper floor, occupying part of the mezzanine level. This relaxation area opens onto the public zone of the house but maintains its privacy.

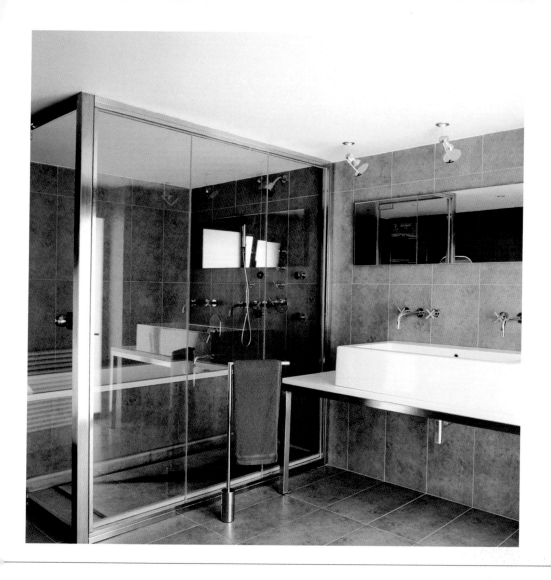

Palmerston Road

Boyd Cody Architects

Photos © Paul Tierney

■ Dublin, Ireland

This project included the expansion of two apartments and the reformation of the rear of a large three-story Victorian in Dublin's south. The inside was modified as well, with the aim of rationalizing spaces and a new bathroom and solarium added, the latter on the roof in order it to enjoy the exceptional views over the city.

Outside, the volumes work as sculptural shapes using a bronze coating and making use of pure geometrical shapes, complemented with large glassed-in areas. The proportions and articulation of the spaces were largely determined by the context and use. The extension takes on an independent character with respect to the rest of the property.

190

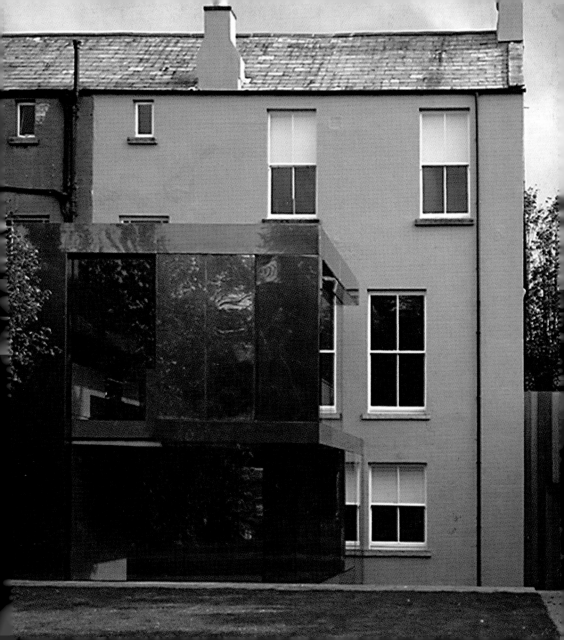

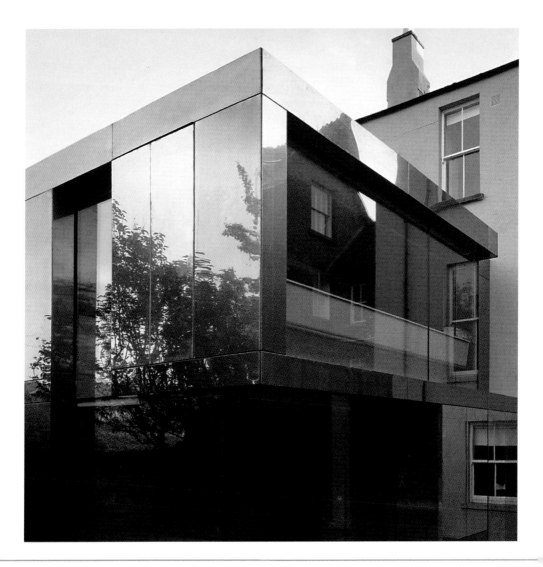

The bronze covering gives the new volume a sculptural appearance.

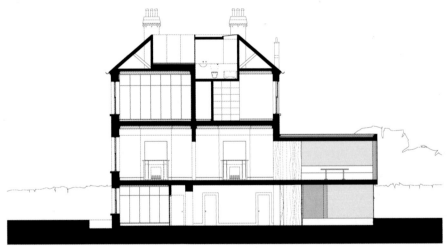

Section of the property and the extension. The new spaces are perfectly integrated into the preexisting areas of the ground and first floors.

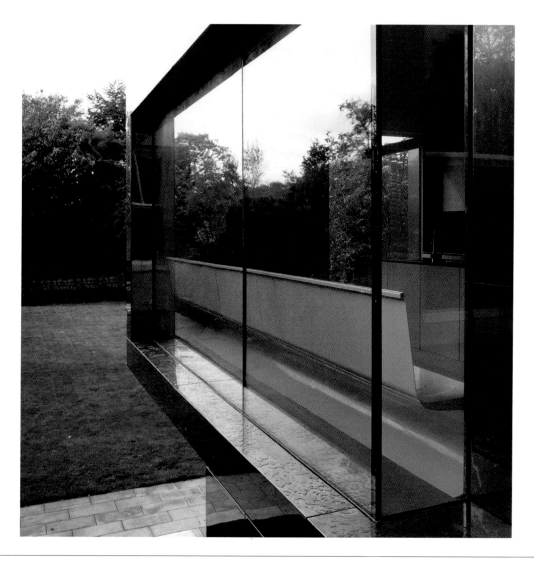

The entry of daylight was optimized via large windows, the use of metal coverings and plastic paint. The staircase, covered in bronze sheet metal, plays with angles and lights.

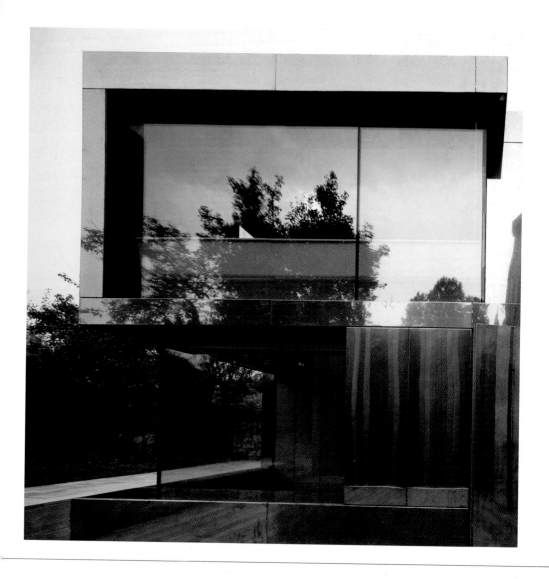

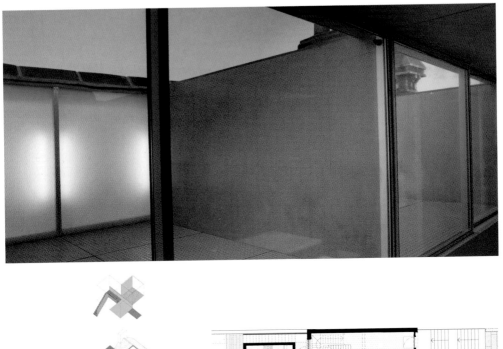

■ Exploded view of the extension and first floor. They show the extended area that serves as a kitchen and the completely glassed-in bar/dining room with views over the garden.

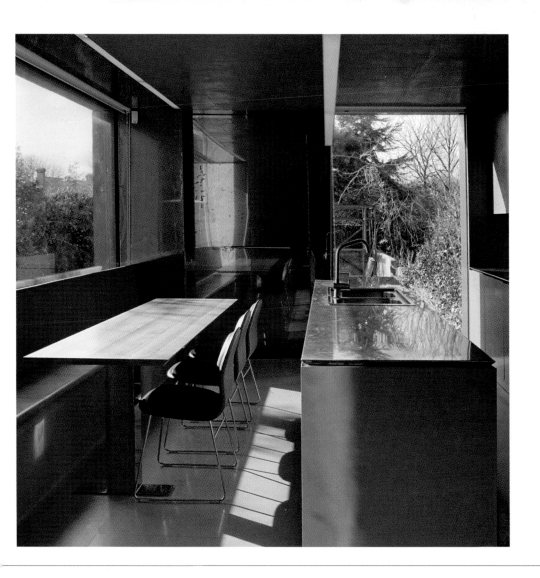

The Black Box

Weysen and De Baere

Photos © Michèle Verbruggen

■ Ghent, Belgium

The old wharves of Ghent were extremely run-down due to their long industrial use. Thanks to an ambitious city-renewal project, this zone has been targeted for house projects like this one, where a former factory from the second-half of the nineteenth-century was turned into a home.

The small budget forced the architects to find a building they could renovate themselves, with the aim of conciliating the grandeur of an old factory with today's housing requirements. To that end, they opted for a box-shaped volume measuring 11½ x 60 feet (3½ x 18 m), modulated in line with the existing metal structure. The position and openings of the box are variable and can adapt to the needs of the owners and the climatic changes of each season.

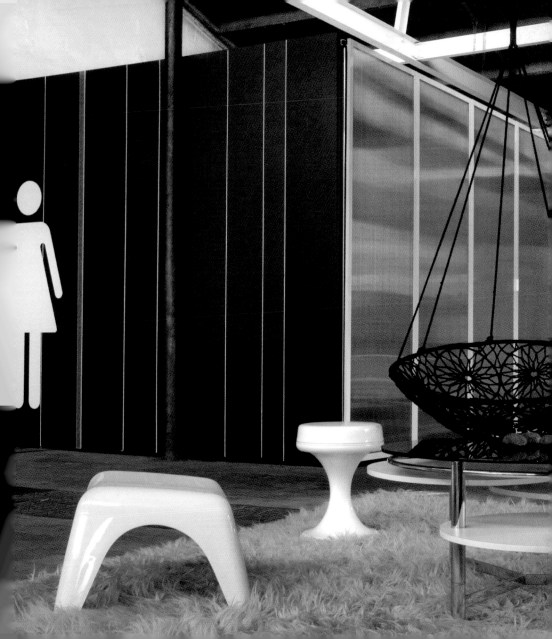

■ The box, covered in wood and painted black, stands out powerfully inside.

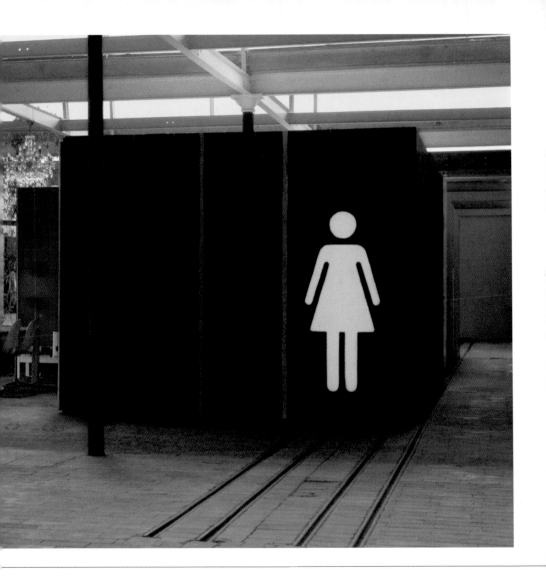

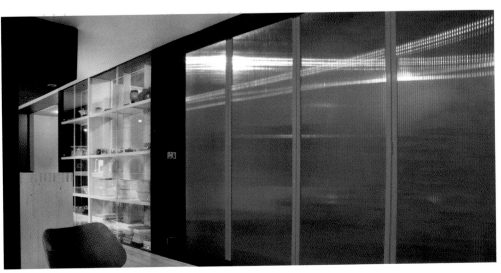

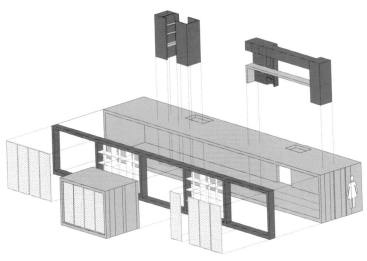

Exploded view. Exploded view of the extension with the black box and the way the modules fit together.

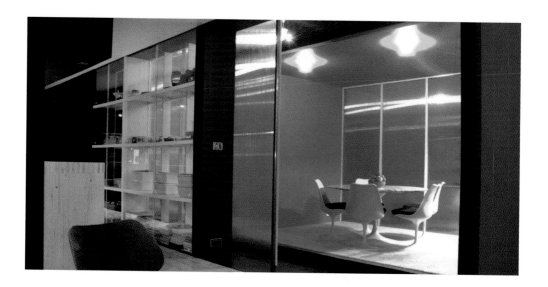

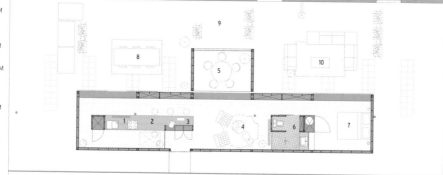

1. KITCHEN
2. DINING ROOM (WINTER)
3. STUDY
4. LIVING ROOM (WINTER)
5. MOBILE ROOM
6. BATHROOM
7. BEDROOM
8. DINING ROOM (SUMMER)
9. LIBRARY
10. LIVING ROOM (SUMMER)

Ground floor. Distribution of the different spaces of the residence. The dining room and the living room are located outside the box during the summer.

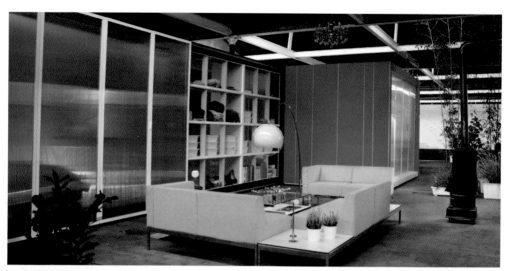

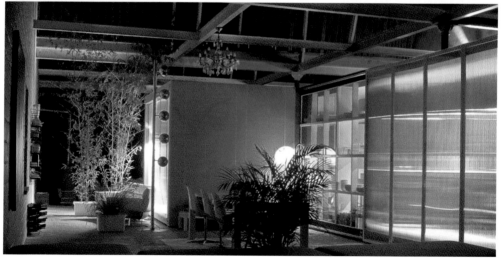

Ojito Residence

I-Beam Design

Photos © Farzad Owrang

■ New York City

The clients sought the creation of a space that was both a home and art gallery, based on a new spatial concept where permanent coexistence with works by artists such as Wilfredo Lam and Amelia Peláez was paramount, as well as pictures pertaining to the Southern School and Concrete Invention art movements.

This remodeling is fruit of the collaboration between architecture studio I-Beam and the painter Joan Waltemath, which managed to unite in the joint work the two-dimensional skills of the artist with the three-dimensional vision of the architects.

The property's various rooms fan out around the axis formed by the hall and balcony: a guest bedroom, living room, study, open-plan dining room, and numerous cabinets.

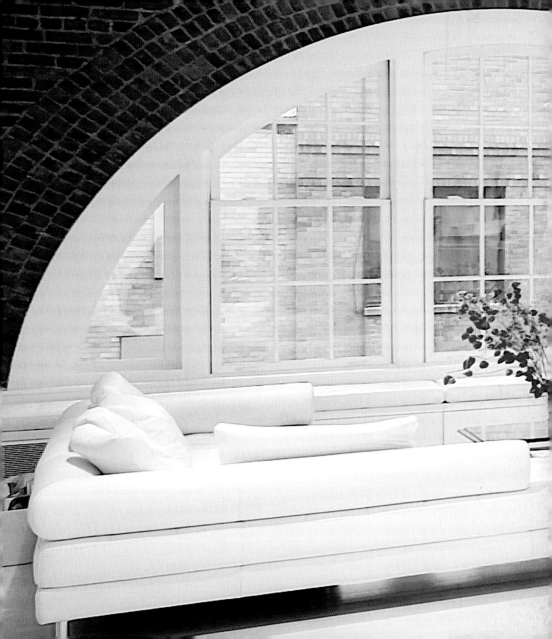

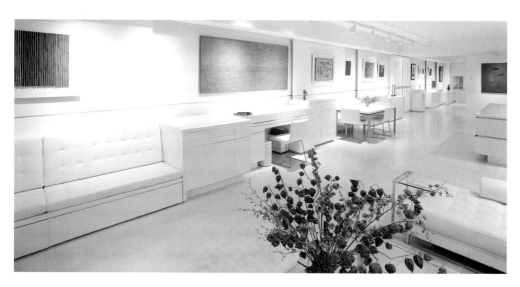

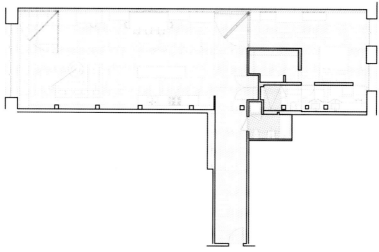

Floor plan. T-shaped floor plan with the middle section divided into three modules. One is occupied by the central bedroom and bathroom, while the others boast the kitchen, dining room, living room, and guest bedroom.

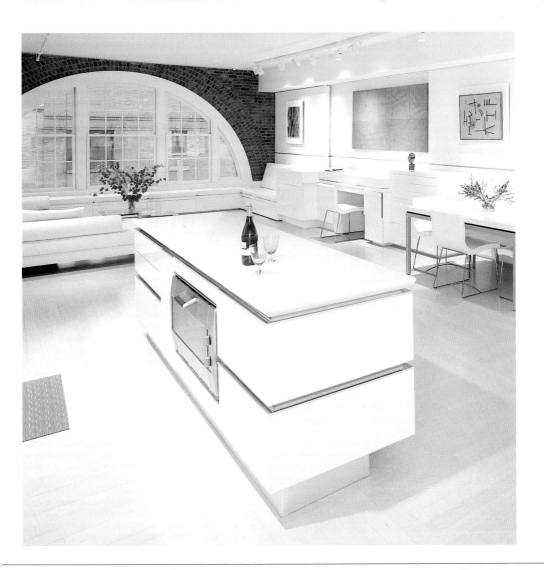

■ The white space is designed as if it was an art gallery, in which the works by Wilfredo Lam and Amelia Peláez, which are the real protagonists, stand out.

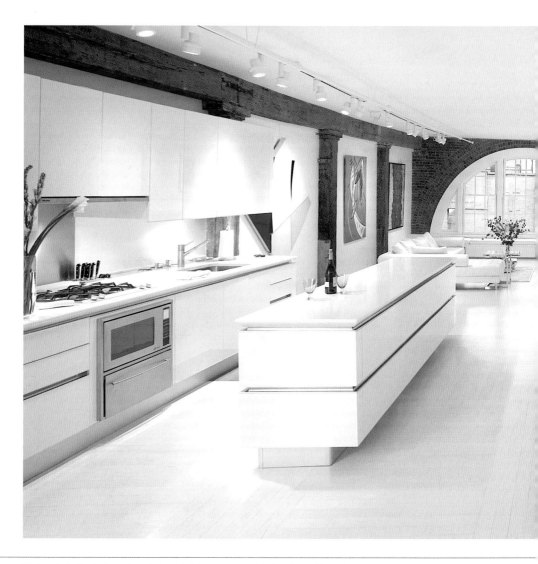

■ Of note is the texture of unplastered brick masonry which, together with the beams and untreated wooden columns, is the exception to the general aesthetic treatment.

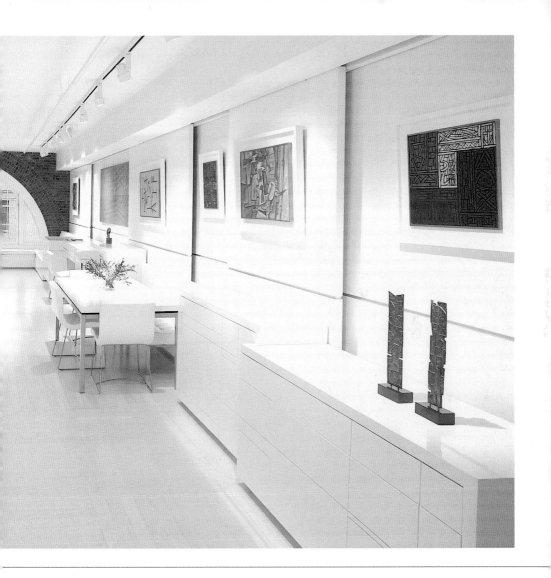

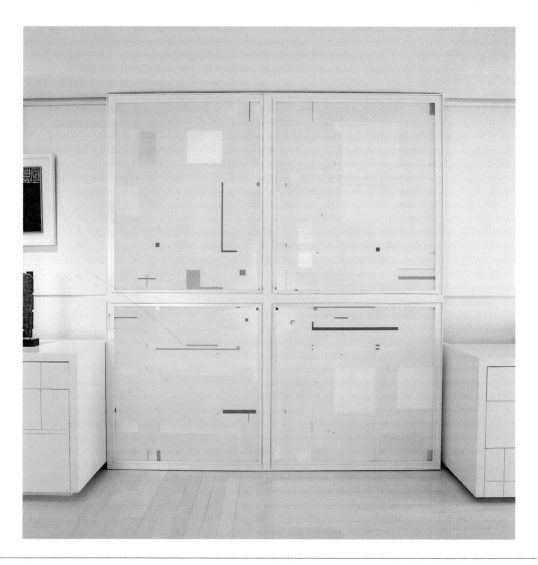

■ From the entrance one can see the panel that marks the middle point of the rear wall. The space becomes an extraordinary work of art which unites painting and sculptures in the one property.

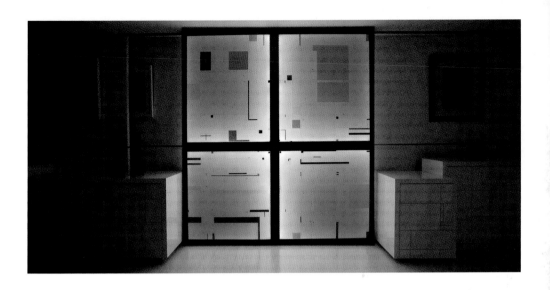

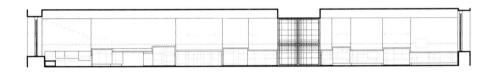

Longitudinal section. The longitudinal section cut clearly shows the location of the central panel, which stands out because of the height difference of the ceiling.

Alikhani/Petroulas Penthouse

I-Beam Design

Photos © Silke Mayer, Andreas Sterzing

■ New York City

Located in the heart of NoHo, this loft was remodeled for a couple with modern taste and a profound interest in design and experimentation.

The design is based on an elongated central area, marked at the ends by the bedrooms with their respective bathrooms. The wall-free space has numerous pieces of purpose-built furniture based on multiple mobile elements to satisfy a great variety of functional requirements.

A staircase with stainless steel steps rises from a kitchen module integrated at the bottom to a children's playroom and the garden. The resistant glass steps produce a spectacular visual effect.

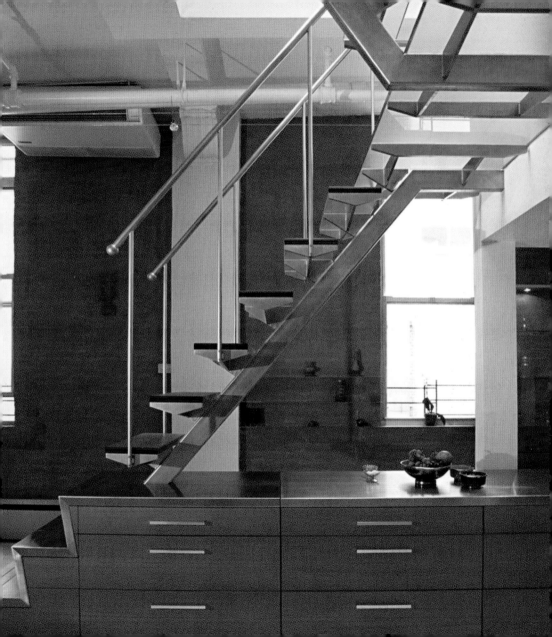

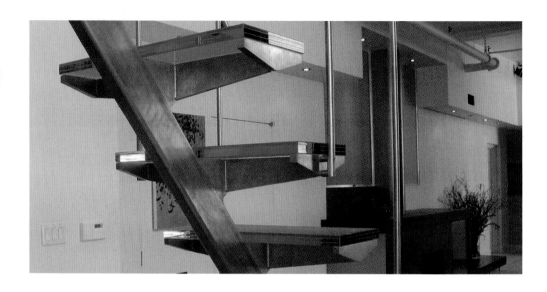

Floor plan. The loft floor plan clearly shows the distribution of the service area, supported by the dividing wall, and of the bedrooms at the either end to free up the central zone for social use.

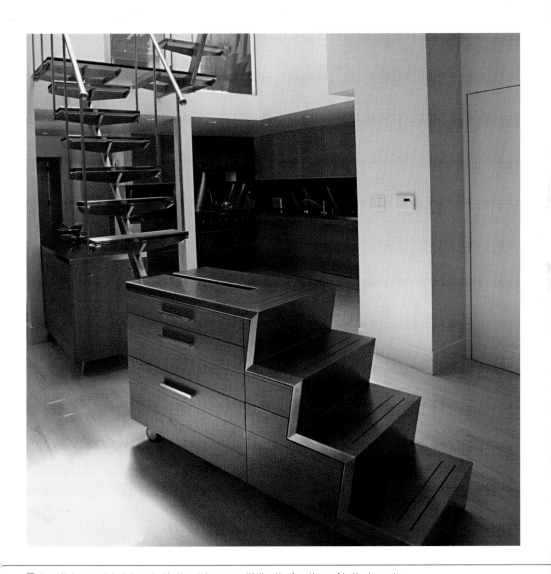

■ The kitchen module, integrated in the staircase, multiplies the functions of both elements.

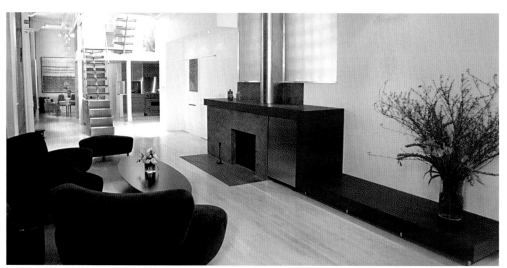

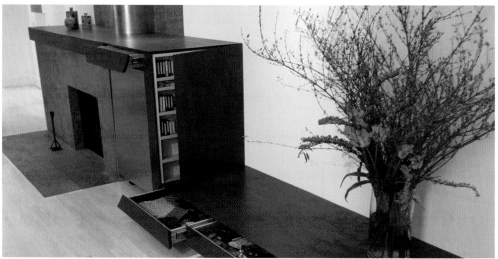

In the living room, a mahogany-colored mantelpiece covers the slate hearth and integrates various compartments for storing CDs and videotapes; a low cabinet with drawers houses the couple's antiques collection.

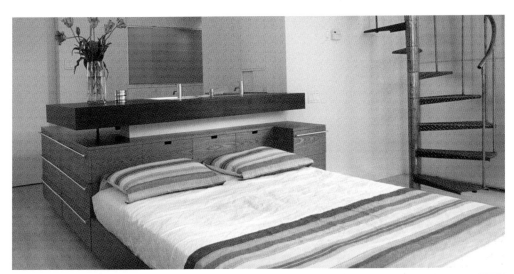

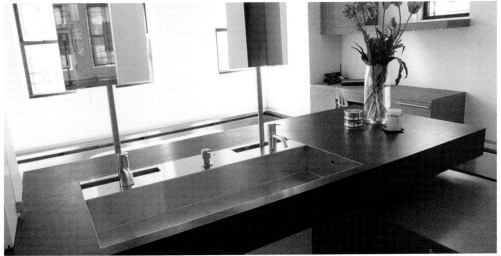

White Space

Hanrahan Meyers Architects

Photos © Michael Moran, Paul Warchol

■ New York City

Located in Central Park West, this apartment is designed as a second residence for a young couple whose main home is in Westchester, New York. The clients asked the architects for an urban bolt-hole in the middle of town where the views over the park would be the main feature.

The White on White series of paintings by Kasmir Malevich, the founder of Suprematism, was the starting point for this project. The aim was to adopt a similar strategy and superimpose pale tones in all the finishes, although there are also wood surfaces that stand out against the white and generate points of visual attraction.

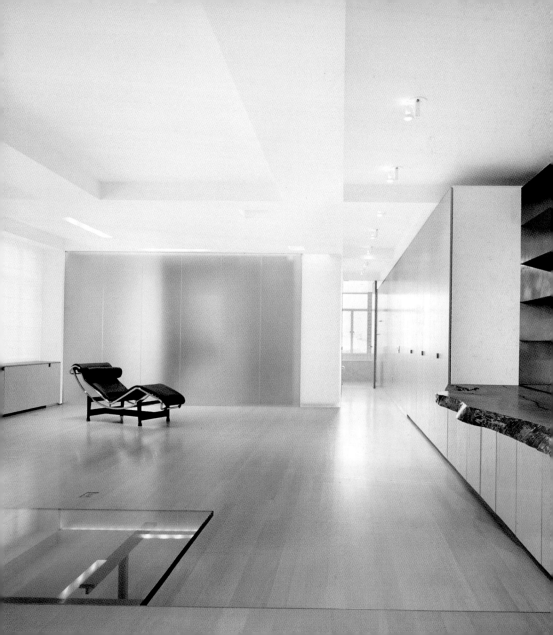

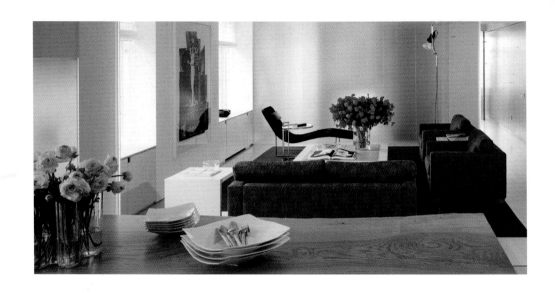

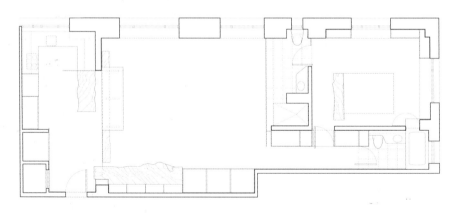

■ Floor plan. The floor plan of the apartment is based on minimalist lines. Three areas are perfectly marked out but the only completely separate space is the bedroom.

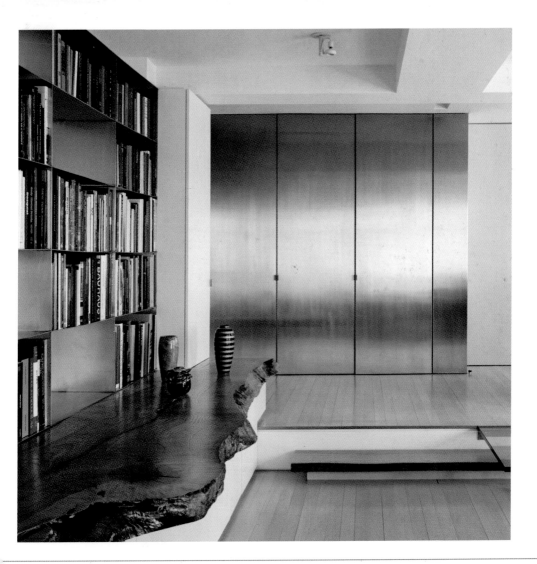

■ A stainless-steel closet stands out in this completely open-plan space. Behind it is the kitchen, separated from the rest of the property by emery-polished glass and a solid wooden board used as the dining room table.

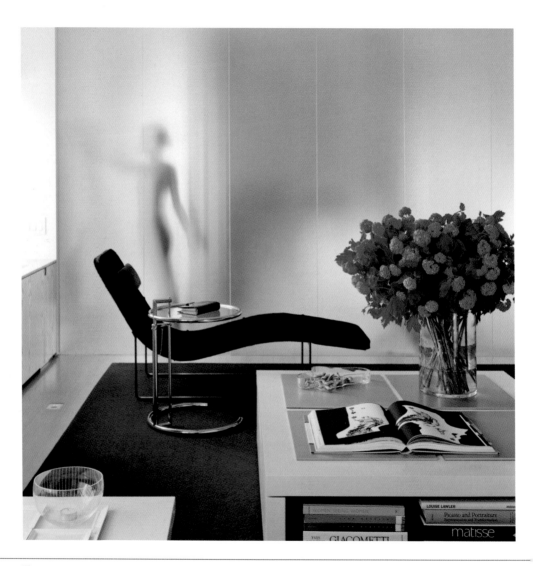

The revamp mainly involved knocking down all the walls and turning a second bathroom into the main one, which is separate from the living room thanks to a translucent glass wall. The armchairs are a Jean Michel Frank design for Pucci.

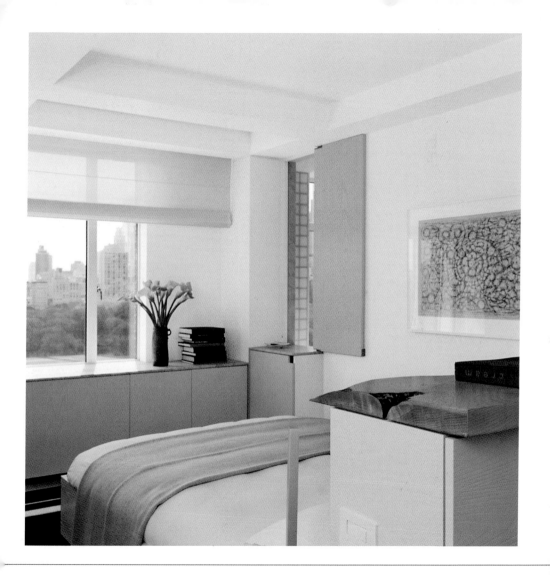

Brooklyn Townhouse

Ogawa Depardon Architects

Photos © Silke Mayer, Andreas Sterzing

■ New York City

The commission involved transforming the ground floor of this property into a bright common area where the family could enjoy films and the children could play, and which opened directly onto the backyard.

To boost flexibility and open up the entry of more daylight inside, a space that had previously been rented was rehabilitated to achieve a larger, more open and translucent environment.

As far as the interior design goes, one feature is the versatility of the furniture and its practical, very useful character. The oak wardrobes in the guest bedroom, which conveniently hide the audiovisual equipment, are particularly beautiful.

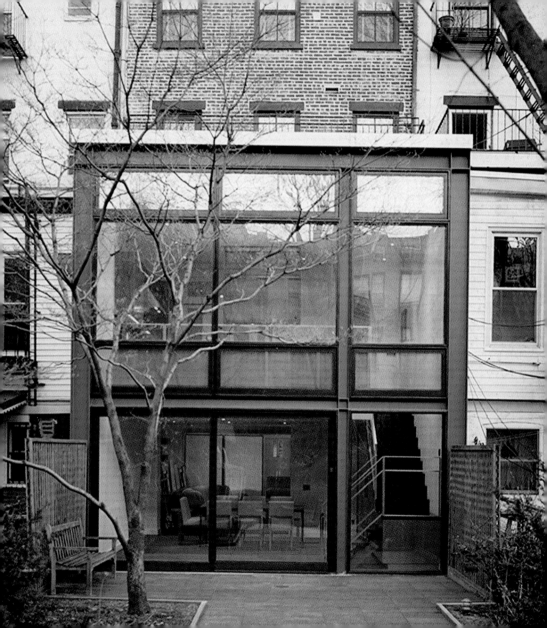

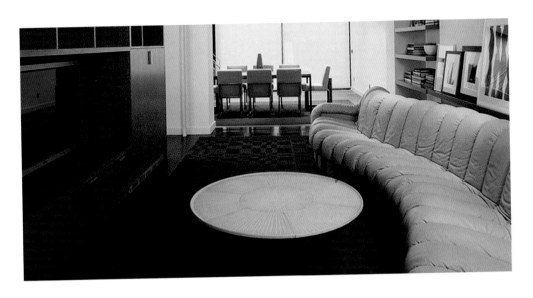

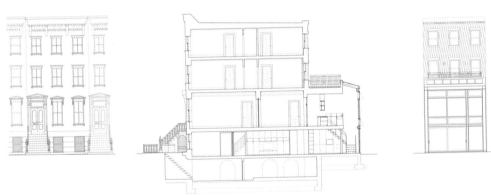

Cross section, and front and rear elevations. A steel structure with wooden windows that covers the two floors enables the light to enter. The bedrooms are on the third floor.

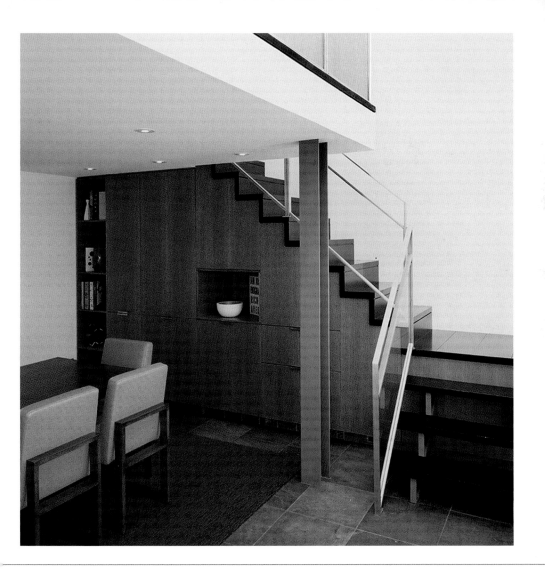

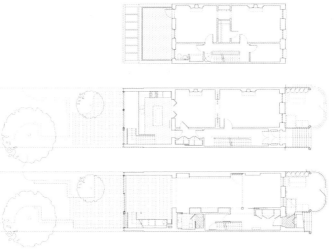

■ Floor plans. The long, narrow floor plan made it necessary to have a minimum number of divisions and to create openings at the ends. The kitchen is located on the second floor of the atrium.

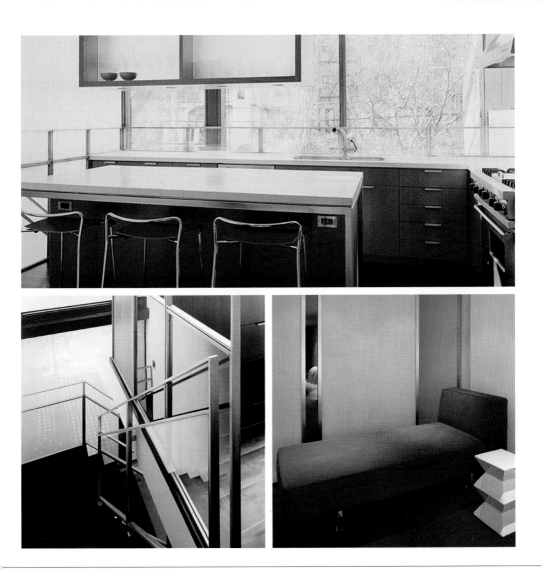

The kitchen, located in the atrium, was completely remodeled following the same design criteria applied to the rest of the property. The plywood workbench is a large volume.

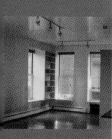

Soho Loft

Thomas Warnke / Space4a

Photos © Space4a

■ New York City

The interior of this loft in Soho was remodeled with the main objectives of opening up the space and underlining the structural elements characteristic of this type of New York property, such as the cast-iron columns and brick walls. This is a classic example of a loft that reuses an industrial building with a residential use.

The most innovative part of the project is a large white wall conceived as an independent element and used to separate the private areas from the public functions. It provides visual continuity to the space and is a multipurpose element, because as well as its separating function, it houses the television set and a bookshelf. The wall is built from plasterboard, a light but solid material that is also very flexible.

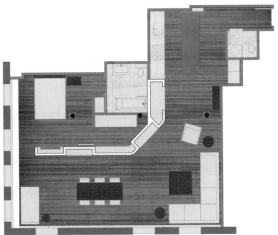

Floor plan. Floor space was gained with the open-plan layout of the rooms. The only private area is the bedroom.

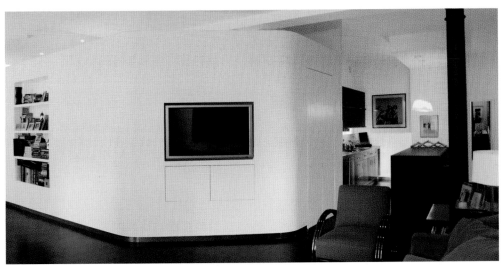

Rendering. Different views and studies done to design the wall, conceived as the main element of the whole renovation work.

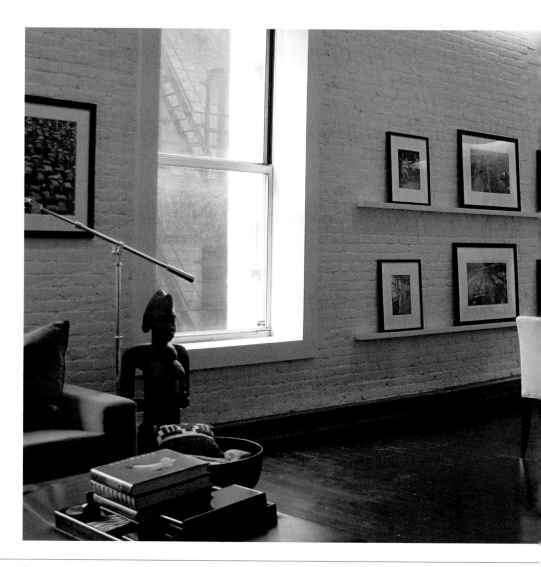

The solid wall in the main space of the loft is an independent entity that brightens up the design. The loft's symmetrical windows are a reminder of the building's industrial past.

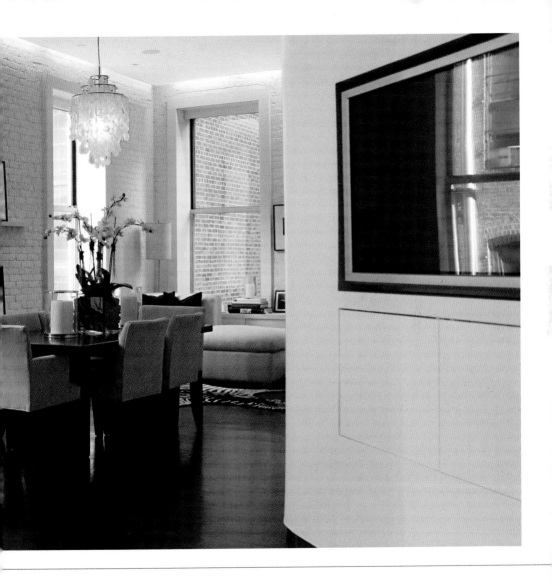

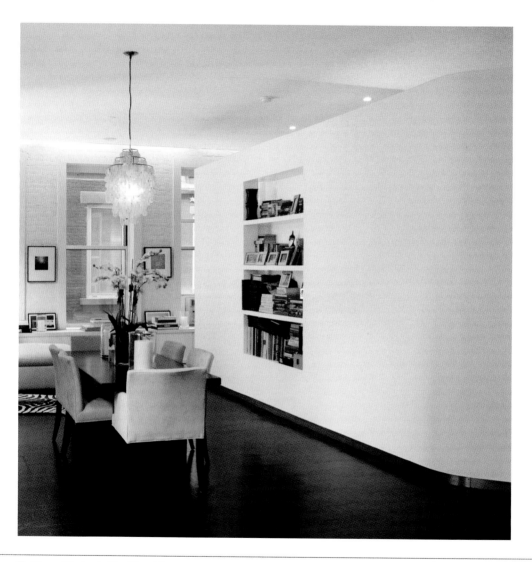

The architect opted for filtered lighting in the false ceiling in the living room. The classical furniture matches the wall on one side.

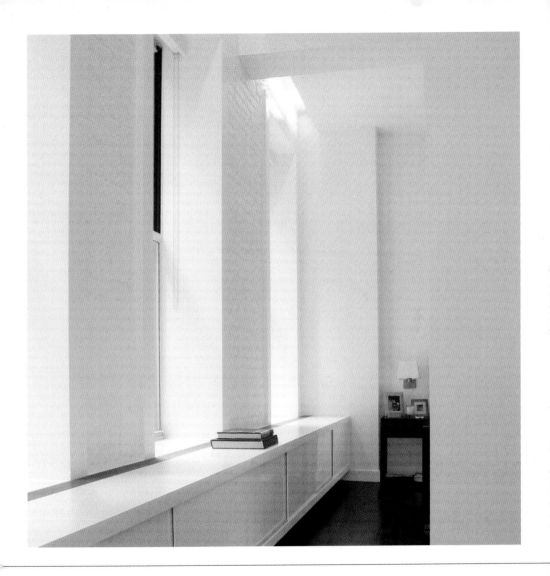

Yaya House

Manuel Ocaña

Photos © Miguel de Guzmán

■ Madrid, Spain

The personal dimension of the commission played a fundamental role in this project. It involved the reformation of a penthouse apartment in the Chueca neighborhood of Madrid. It is the first house the client has owned after thirty years working and living in the hostels she ran and explains why she wanted a project that reflected her personality.

The main feature of the property is the parquet flooring, on which the portrait of the owner has been printed. This involved an exhaustive compositional study, using the left eye pupil as the center.

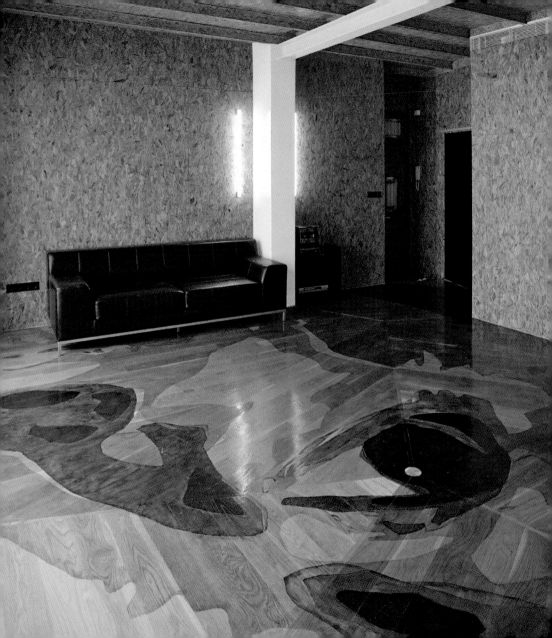

■ With the collaboration of a fine-arts student, a laborious process was carried out that included the use of Photoshop, the Xyladecor wood color range that exists on the market, polyurethane, and a set of cutting tools.

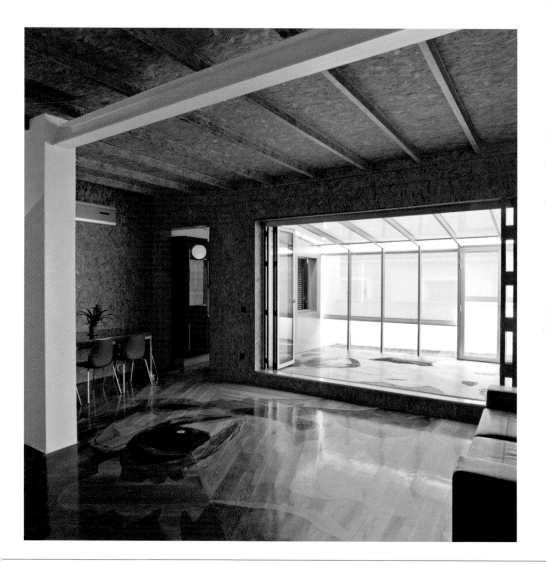

Walls and partitions were built using galvanized profiles from standard plasterboard sheets, replacing them with lighter sheets formed of OSB wood chips.

■ Floor plan. This floor plan of the penthouse apartment shows the work done on the wooden flooring and the distribution of the bedrooms and bathroom.

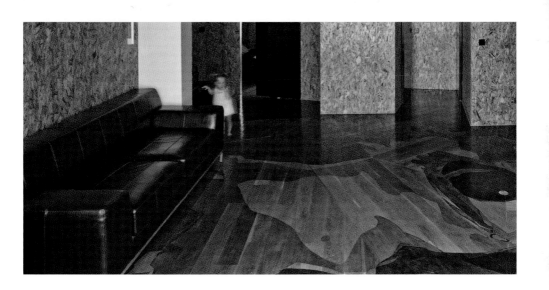

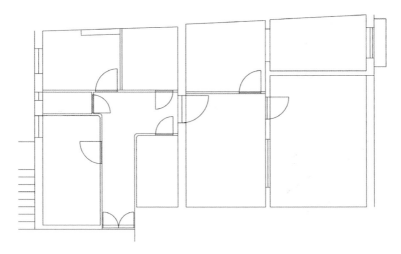

Floor plan. The original floor plan shows a fragmented space which was made bigger with the reform work.

Rota House

Manuel Ocaña

Photos © Miguel de Guzmán

■ Madrid, Spain

The construction of a swimming pool was the main reason behind the reform of this property that belongs to a theater actress. The design converted the space into an interior courtyard with a vertical layout and the pool in the middle. The incorporation of a 14,125 ft³ (4,305 m³)pool of water heated to 98.6°F (37°C) required an exhaustive study of the heating system and particularly the active participation of the owner, who was aware that her domestic life was going to be very similar to that of someone living on a boat.

The original property lacked natural lighting and was extremely dark inside. To solve this, a number of walls were demolished and the cascading floor opened up toward the south, so that daylight could flood the three levels of the home.

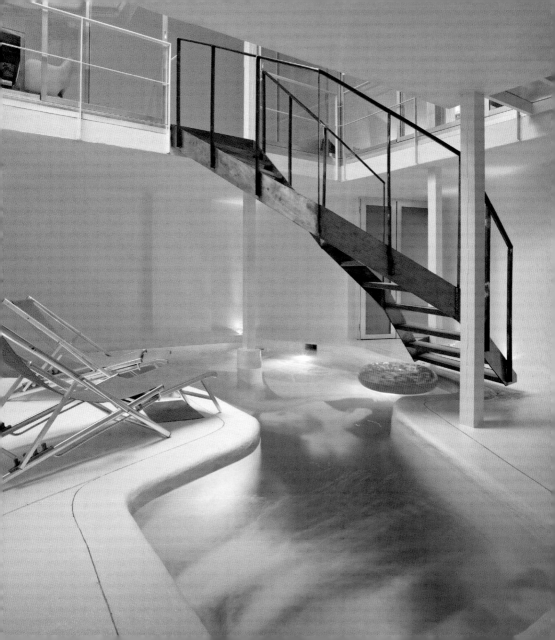

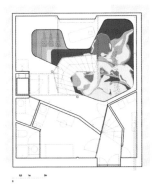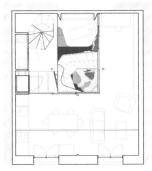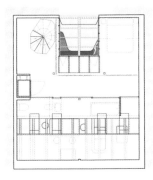

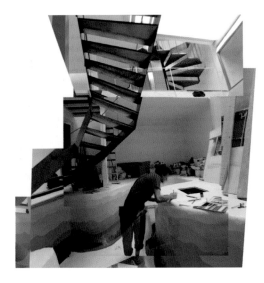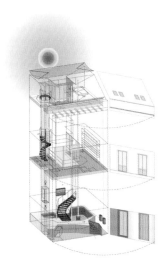

■ Floor plans and axonometry. The axonometric view of the home's three floors also shows the heating and cooling systems. These plans show the spatial relationship between the different floors and the key role the stairs play.

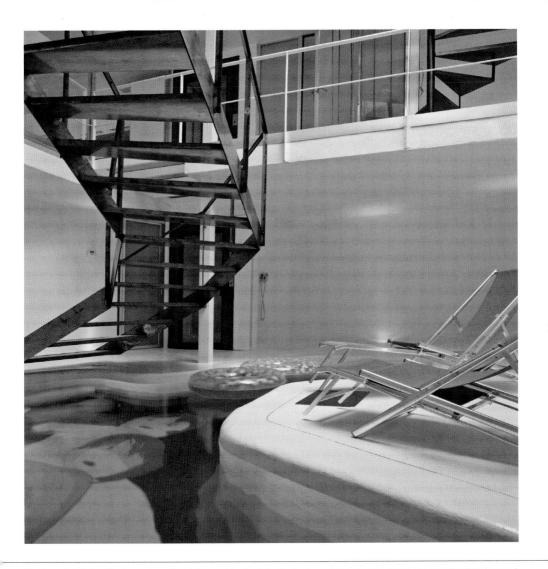

The artist Sebastián Camacho painted the pool to simulate the bottom of the sea. The irregular-shaped swimming pool allows much better use of the space beneath the stairs.

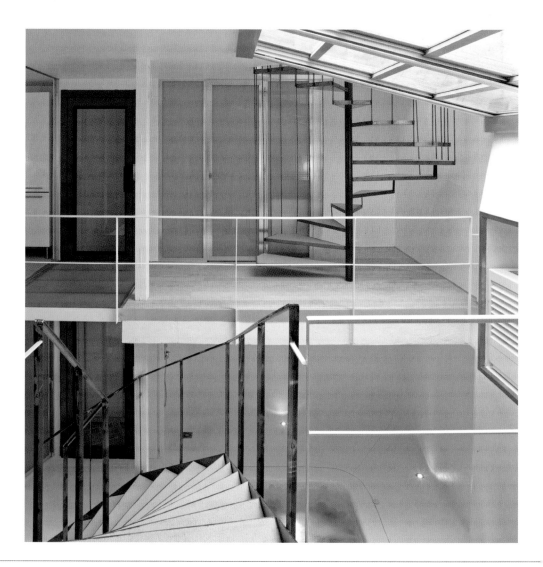

The surface of the water reflects the natural light throughout the interior of the home.

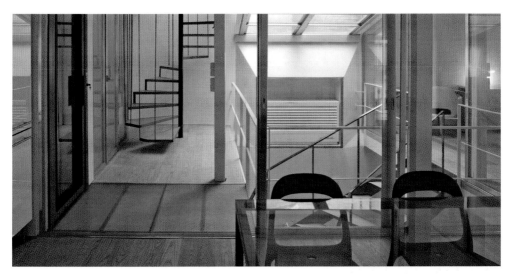

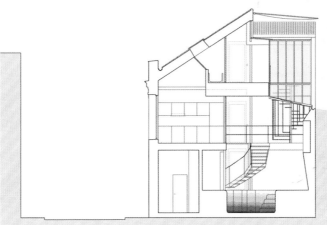

Longitudinal section. The interior appears to be fragmented because of the planes formed by the stairs.

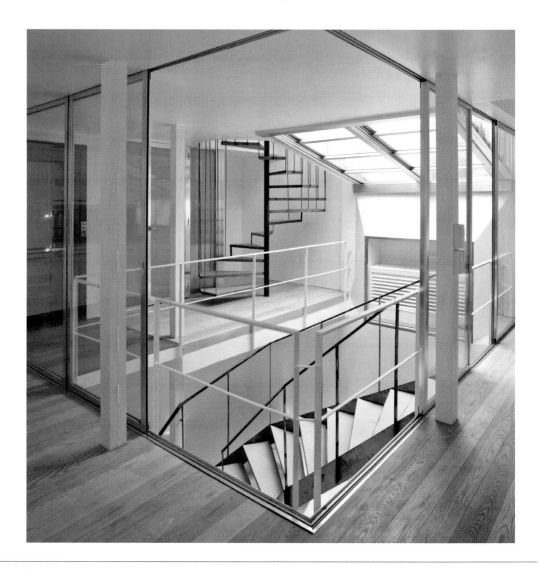

The unique façade of the north-facing house overlooks a dark, narrow street. To boost the entry of natural light, the 6.5 x 6.5 ft. (2 x 2 m) narrow rear courtyard was surrounded by glassed-in walls.

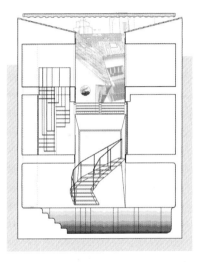

■ Cross section of the inner courtyard. When the walls were knocked down, the interior space became bigger and lighter.

Harlem Townhouse

Front Studio

Photos © Front Studio

■ New York City

Founded in 2001, the firm Front Studio is renowned for its ability to blur the limits between art and architecture. The firm defines its work as an approach to the creative thought of design.

Reluctant to follow current trends too faithfully, the firm assumes a commitment with creativity and submits each project to a careful and exhaustive study to achieve a unique and personal result.

In this case, the project consisted of creating two duplex apartments that fit together on the middle level to make sure both had views from either end of the floor plan, as well as suitable cross-ventilation and a good orientation.

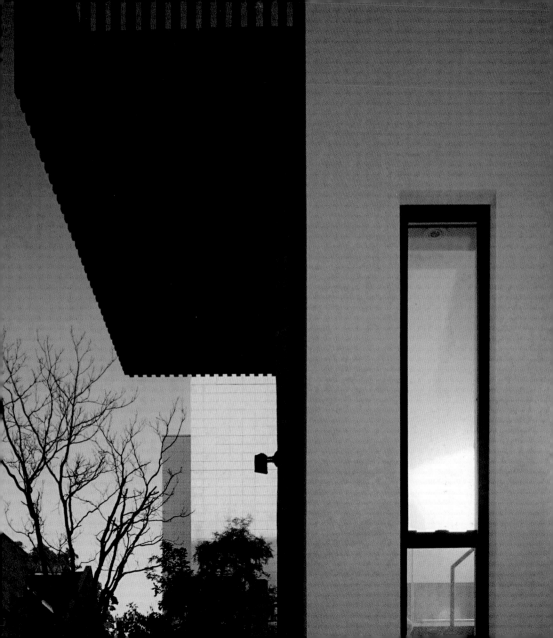

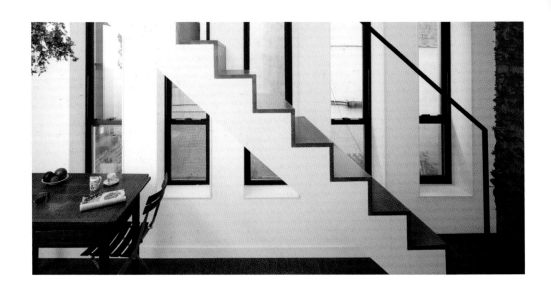

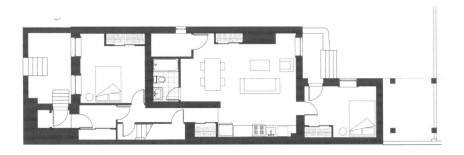

First floor plan before the reform

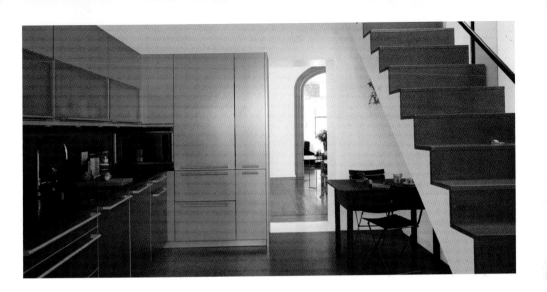

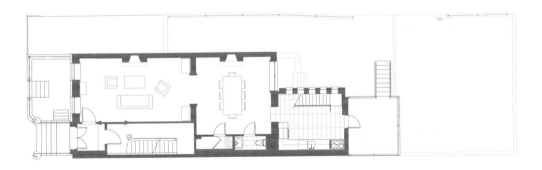

Post-remodelling plan of the first floor.

Doc Blue

Elliot & Associates Architects

Photos © Bob Shimer, Hedrich Blessing

■ Bricktown, Oklahoma City, Oklahoma

The renovation of this property, located on the fifth floor of an early-twentieth-century warehouse, was commissioned by an orthodontist with eccentric taste. The goal was to create a space related with the personality of its owner, seventy-year-old Doc Blue, a blues songwriter and former race car driver.

Using two important references to Doc (i.e., the color blue and the exotic furniture he has accumulated over his lifetime) as the starting point, the architect began to configure the spaces of the home on the large floor plan of the pre-existing warehouse.

Various hallways, staircases, and different levels connect the bedroom, the circular living room which appears to float above the kitchen, and a semicircular corner around the fireplace.

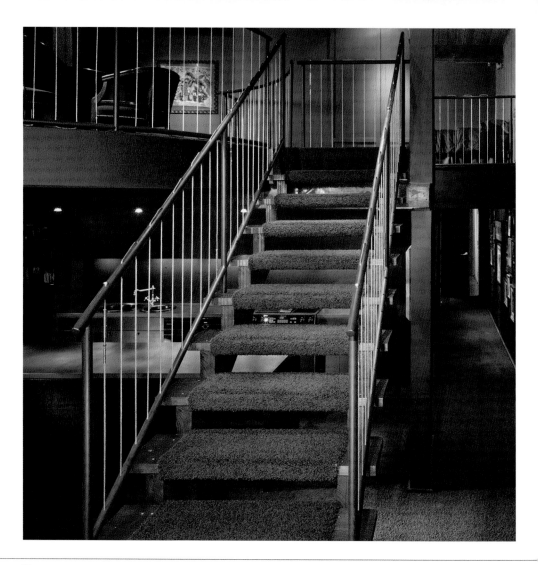

The bedroom, the circular living room that floats above the kitchen, and the chairs in a semicircle that surround the wood stove are connected via bridges, stairs, and different levels, making the home really vibrant.

Ground floor. Two separate areas were designed: a public area with a semicircle shaped lounge, and another private, separate space made up of the bedroom and its ensuite rooms.

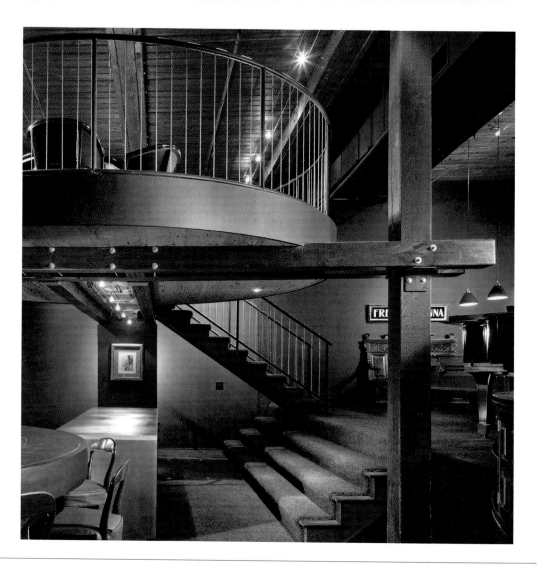

The circular living room on the second floor is supported on a wooden structure and seemingly floats above the kitchen and breakfast bar. The original wood that has been restored and protected is maintained in the structural elements.

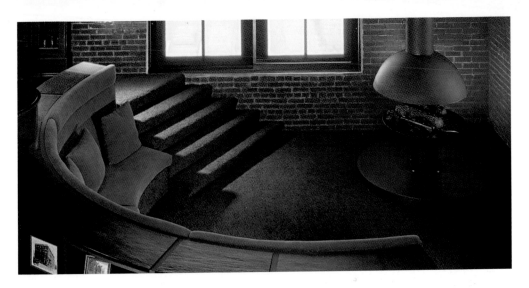

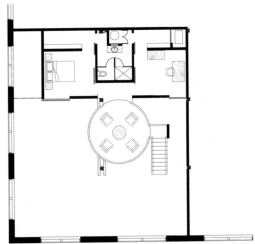

Second floor. The second floor has an area for socializing that consists of a circular lounge raised over the kitchen counter, and another more intimate space, containing a second bedroom, the main bathroom and the office.

Some furniture items and personal objects have been arranged like sculptures, creating points of visual attention. Both the designer furniture and the color blue are constant features throughout the home.

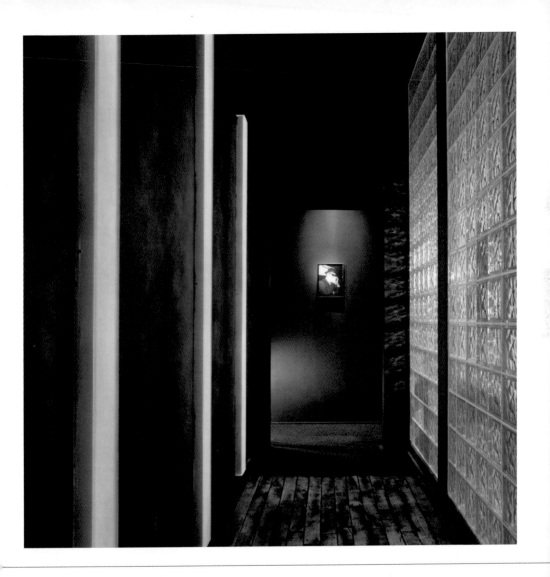

Sheridan Residence

Simon Anderson/Anderson Architecture

Photos © Nick Bowers

■ Sydney, Australia

Simon Anderson was the architect responsible for the renovation of this art deco apartment in a 1930s building on a cliff.

The work had to make the most of a small area of just 732 sq. ft. (68 sq. m) and ease communication between the living areas and bedroom. The windows were lowered to floor level to enhance the sea views.

It is also an ecointelligent apartment that features the inclusion of a "C-bus" control system for the lighting and household appliances programs, which works in the same way as a security alarm system.

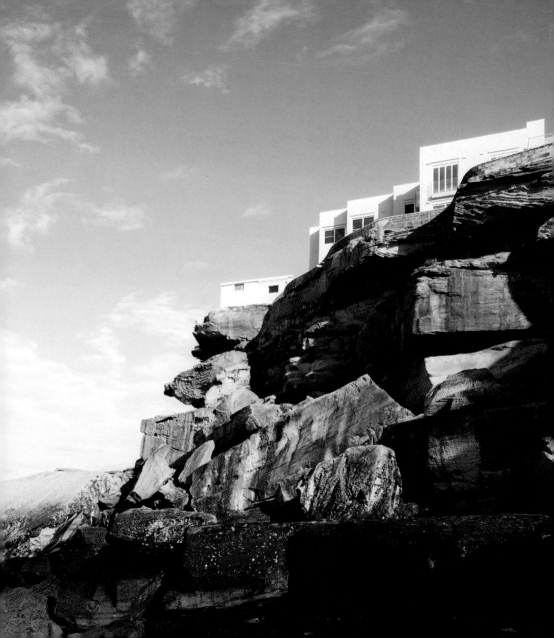

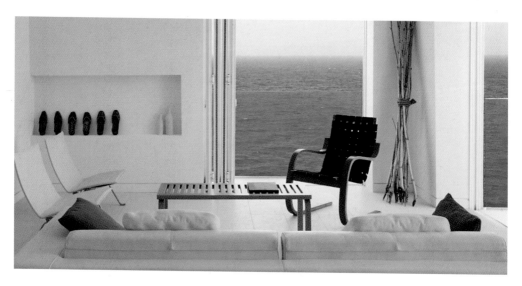

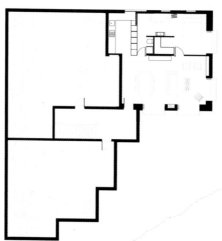

Floor plan. The living room, dining room, and kitchen practically share the same space, while the bedroom, dressing room, and bathroom are separated by subtle wall details.

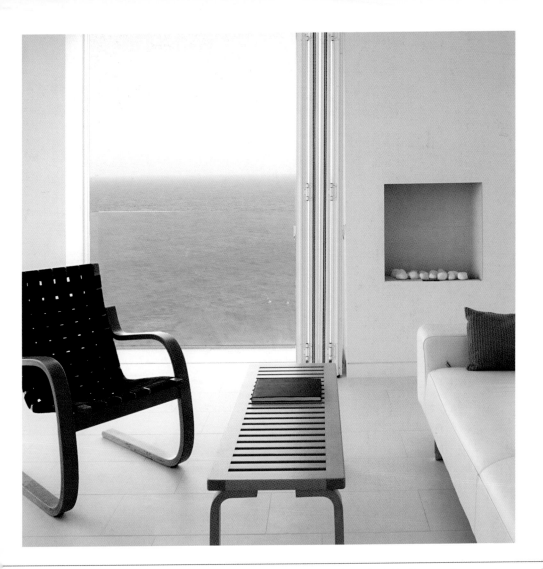

■ The clearly minimalist-inspired room boasts the floor-length window that offers unbeatable views over the sea and also lets in the sound of the waves.

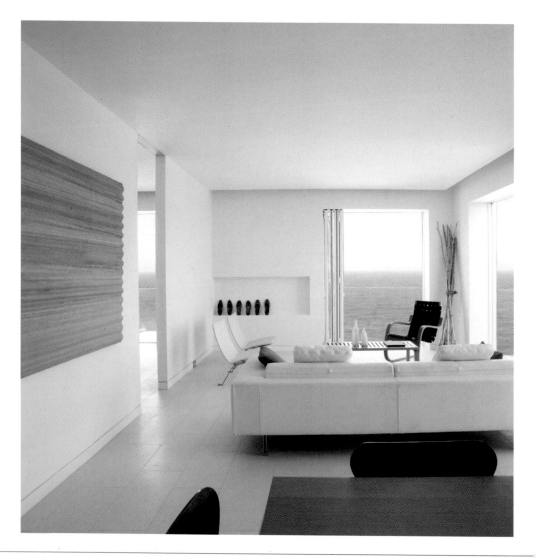

■ In the living room, a lighting system with an automatic control system makes it possible to enjoy a gentle ambiance at night.

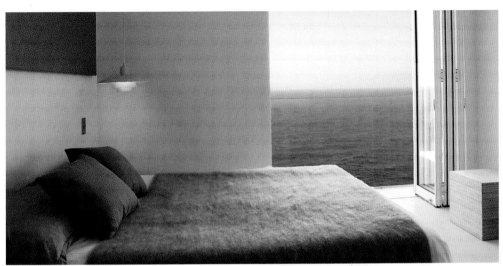

Urban Residence

La Dallman Architects

Photos © Don F. Wong Photography, La Dallman Architects

■ Milwaukee, Wisconsin

Playing especially with light, area, and volume, this project has transformed a 1960s residence into a multi-family building.

The very tall building is set on the shore of Lake Michigan. Like many cities in the American Midwest, Milwaukee has lost thousands of inhabitants, whose departure has left empty buildings that are now being turned into apartments to provide housing for lower-income families who cannot afford such large spaces. This project represents a commitment to urban living and experiments with materials, light, and volumes.

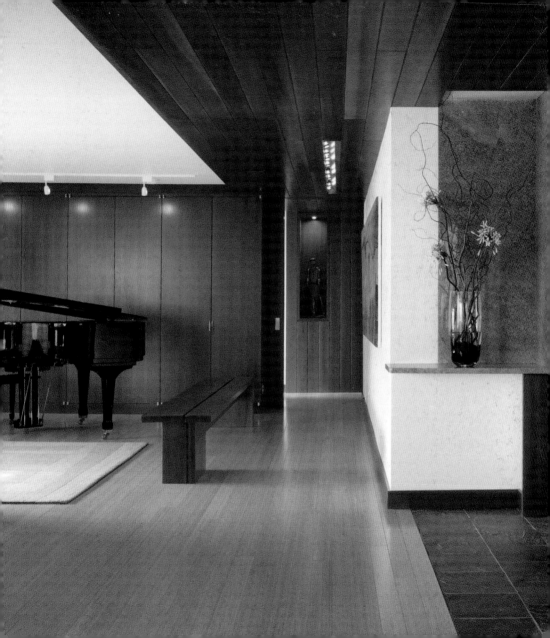

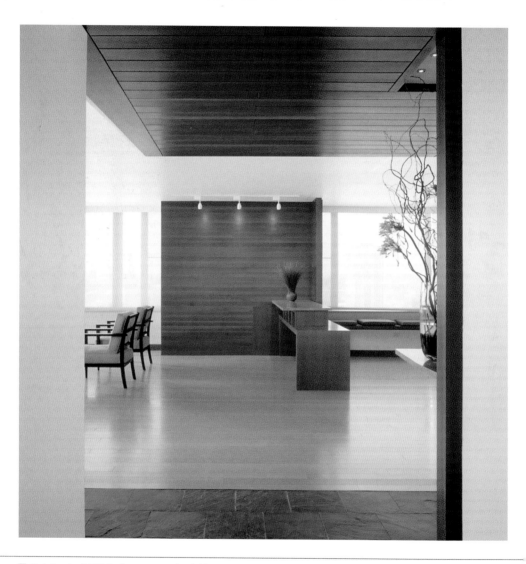

■ To bring daylight into the rooms, up to eighteen walls were knocked down and the space significantly transformed.

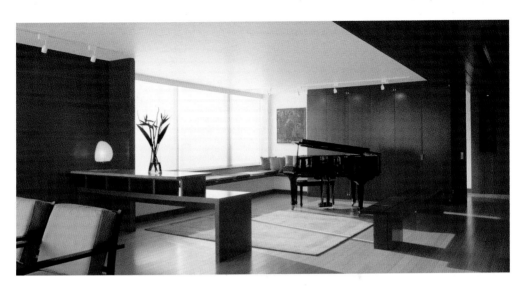

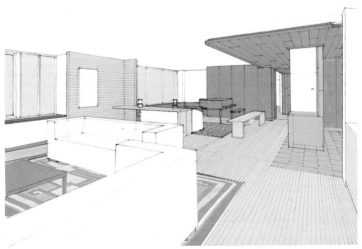

Interior view. The layout of the wooden floorboards accentuates the horizontal nature of the space.

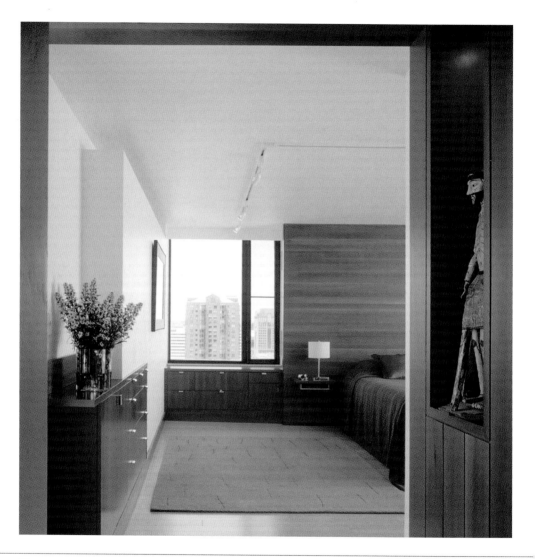

■ Inside, the horizontal wooden floorboards and furniture modules appear to extend the space beyond the building's limits.

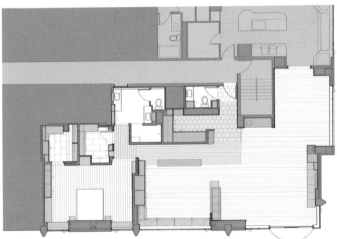

Floor plan. The open-plan design configures a fluid interior. The floor plan shows the apartment's relationship with the rest of the building.

Christodora Penthouse

Lyn Rice Architects

Photos © Lyn Rice Architects

■ New York City

This project consisted of the unification and renovation of three floors and four balconies in two apartments built in 1926, located at the top of a historic seventeen-story building.

The architects' main idea was to divide the space into two well-defined zones: the winter area and the summer area, which could be differentiated particularly by the materials used. The area that faces north, considered the winter area, is a warm and intimate space, organized around the previous building and limited by the dining room and kitchen. In the southern section, the summer area is larger and characterized by fresh colors and a more flexible distribution. A billiard table with a gray cover marks the epicenter of this part of the house.

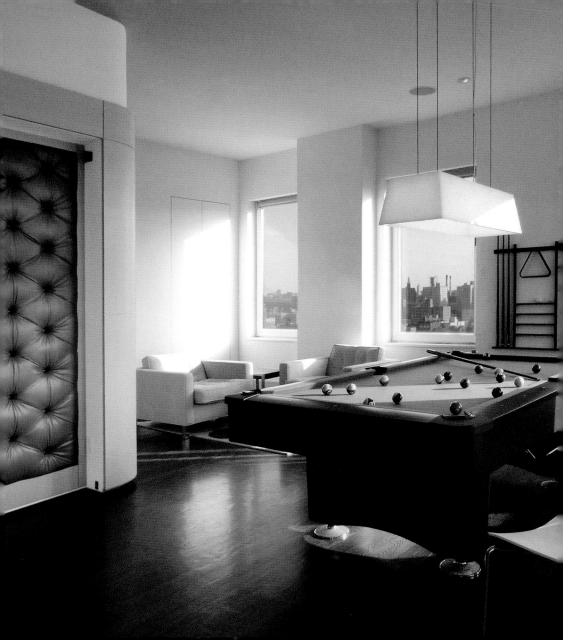

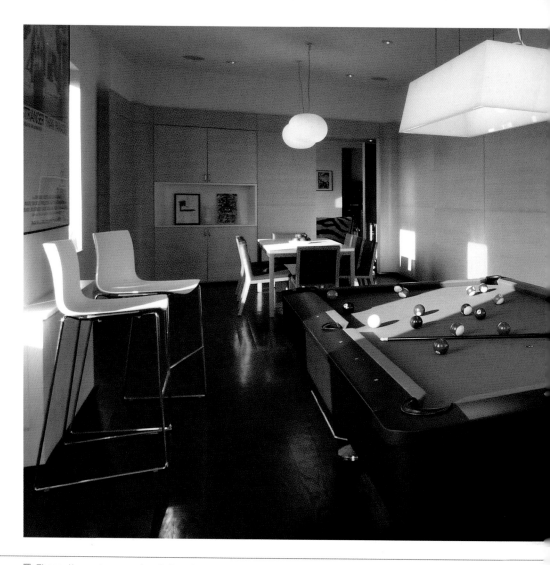

■ The south area has a spacious L-shaped space that serves both a gameroom and lounge. It features a billiards table that separates the lounge from the dining room.

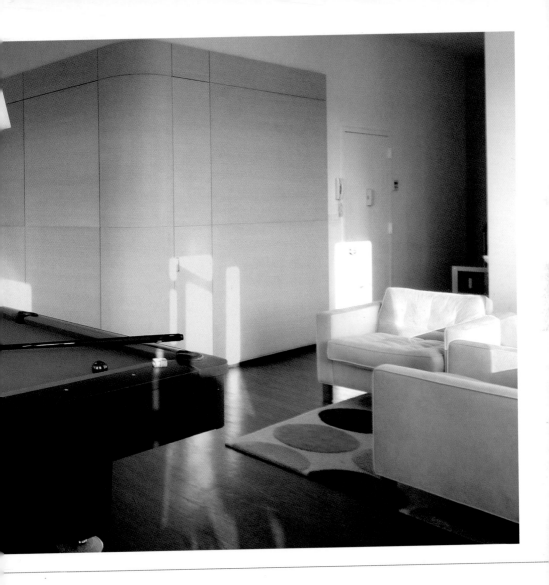

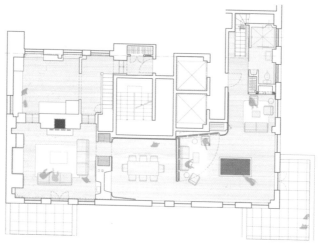

Floor plan. This plan clearly shows the reform work done: small, closed spaces were maintained in the former, while in the latter a versatile and flexible large space was generated, which can be subdivided if necessary.

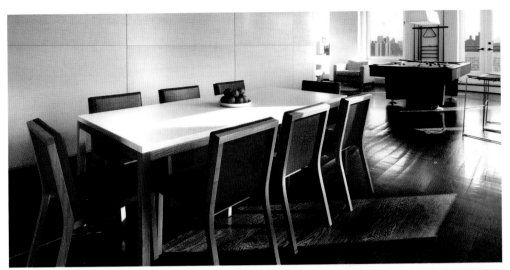

The balconies were joined together to provide a 70-foot (21 m) long deck at the height of Tompkins Square Park. From there, the views over Manhattan, Brooklyn, and Queens are spectacular.

Merced 450

Albert Tide / Tidy Arquitectos

Photos © Cristian Barahona

■ Santiago de Chile, Chile

This revamp project recovered a 2,368 sq. ft. (220 sq. m) flat in the Caja Nacional de Periodistas y Empleados building in Santiago de Chile. The apartment is on the top floor of the four-story building, which made it possible to improve the natural lighting conditions via different sky-lights.

The room distribution respected most of the original 1934 configuration and the work focused on recovering the flooring throughout the apart-ment, except in the bathrooms. The original ironwork was also restored and the outside windows replaced with thermo-panels.

The general aim was to spark a dialogue between the original and the contemporary, boosting the heritage value of one of the first modern buildings in Chile.

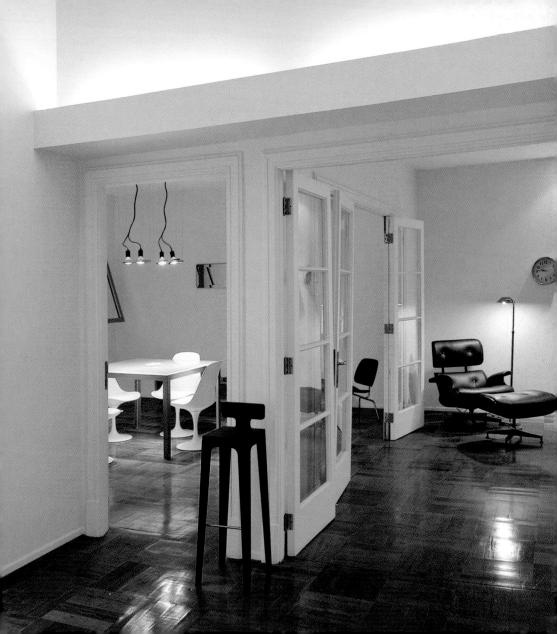

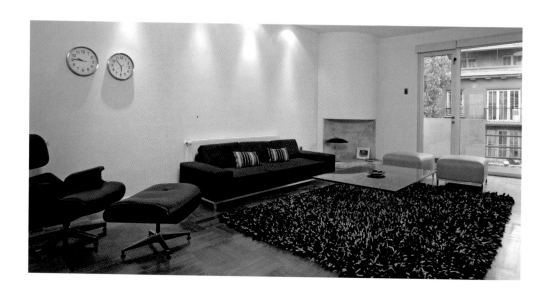

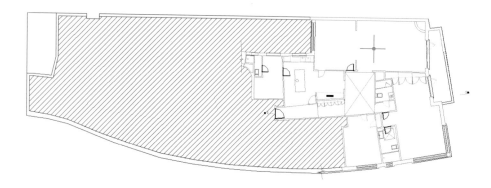

General floor plan. In the middle is the hall which leads to all the rooms in the property. The same area is taken up by a skylight, which because it adapts to the building's limits, does not change the perception of the façades.

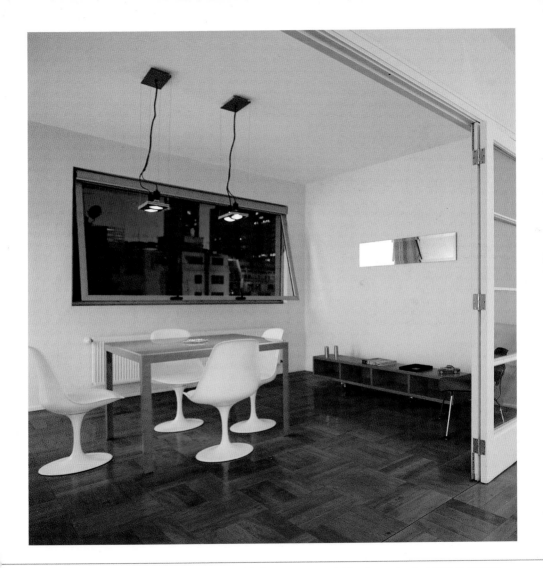

Although the dining and living rooms are integrated in the same space, a folding door makes it possible to separate them and create privacy when needed.

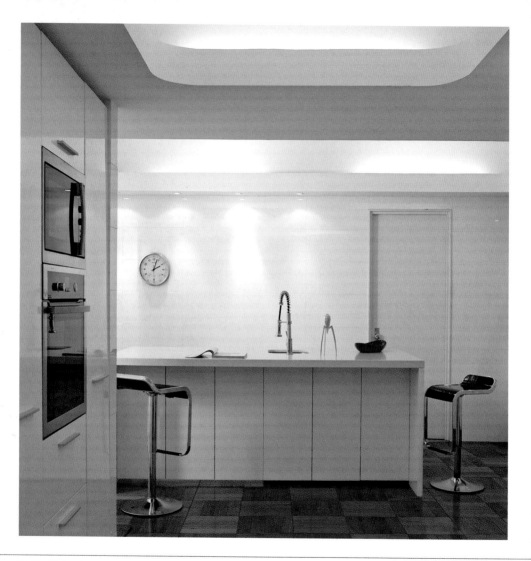

■ The kitchen furniture is made from lacquered MDF boards with Zeus white silestone worktops; of note in the middle is the worktop in the form of an island with two chrome steel stools. White favors the feeling of space.

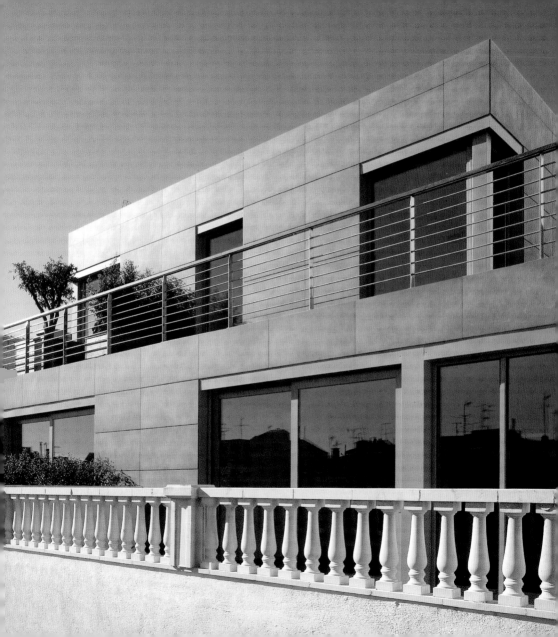

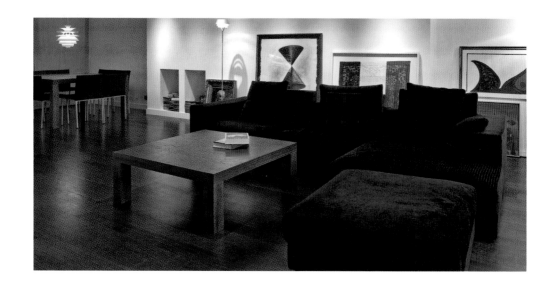

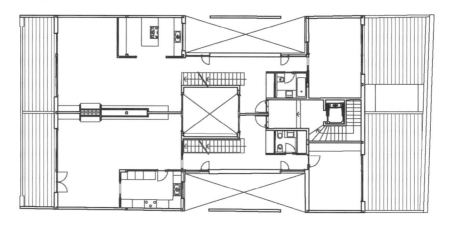

Floor plan. This plan shows how the dwelling space was distributed after the remodelling.

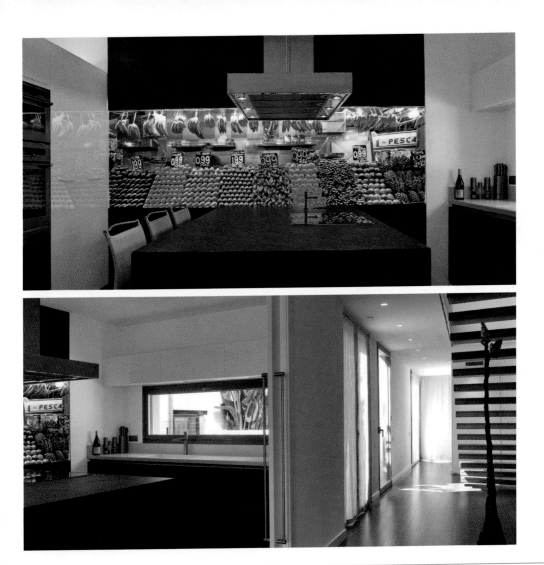

The spaces are big and flexible. The laminated-wood sliding doors are adapted to the width of the kitchen and used to separate the dining room from the living room. Behind, an internal courtyard provides natural lighting for the hall.

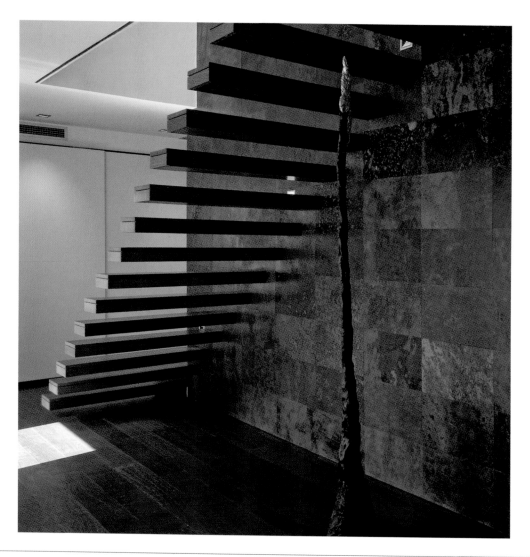

The floating staircase is a steel structure in which each step is independently fastened to the wall with brackets. The steps are covered in Merbau wood and the supporting wall is made from slate.

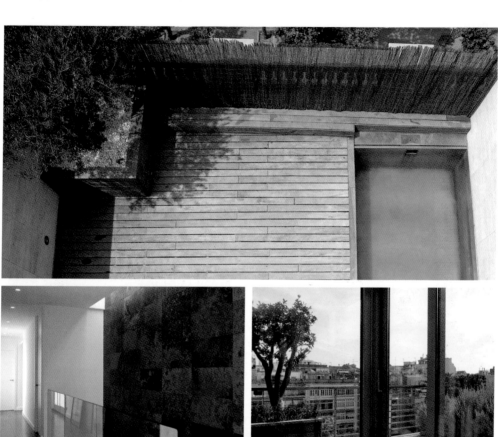

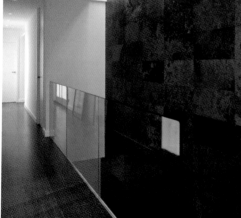

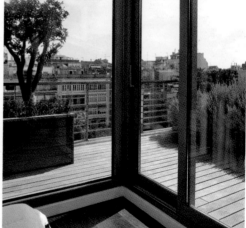

Directory

Aidlin Darling Design
500 Third Street, Suite 410
San Francisco, CA 94107, USA
Tel: +1 415 974 5603
Fax: +1 415 974 0849
info@aidlindarlingdesign.com
www.aidlindarlingdesign.com

Alexander Gorlin Architects
137 Varick Street, 5th Floor
New York, NY 10013, USA
Tel: +1 212 229 1199
Fax: +1 212 206 3590
wdavis@gorlinarchitects.com
www.gorlinarchitects.com

Anderson Architecture
37-45 Myrtle Street Chippendale, Suite 2A
Sydney, NSW 2008, Australia
Tel: +61 293 190 224
Fax: +61 293 180 511
simon@andersonarchitecture.com.au
www.andersonarchitecture.com.au

Bevk Perovic Arhitekti d.o.o.
Tobacna 5
SI-1000, Ljubljana, Slovenia
Tel: +386 1 241 76 30
Fax: +386 1 241 76 37
info@bevkperovic.com
www.bevkperovic.com

Bipolaire Arquitectos
Mauro Guillem 3, puerta 3
46009 Valencia, Spain
Tel: +34 963 476 566
Fax: +34 963 476 626
bipolaire@bipolaire.net
www.bipolaire.net

Boyd Cody Architects
36 College Green
Dublin 2, Ireland
Tel: +353 1 6330042
Fax: +353 1 6330041
info@boydcodyarch.com
www.boydcodyarch.com

Buchner Bründler AG Architekten BSA
Utengasse 19
4058 Basel, Switzerland
Tel: +41 61 301 01 11
Fax: +41 61 303 97 70
mail@bbarc.chwww.bbarc.ch
www.bbarc.ch

Coast Gbr
Helfferichstrasse 1
70192 Stuttgart, Germany
Tel: +49 711 25 98 540
Fax: +49 711 25 98 541
coast@coastoffice.de
www.coastoffice.de

Elliot & Associates Architects
35 Harrison Avenue
Oklahoma City, OK 73104, USA
Tel: +1 405 232 9554
Fax: +1 405 232 9997
design@e-a-a.com
www.e-a-a.com

Front Studio
239 Centre Street, 3rd Floor
New York, NY 10013, USA
Tel: +1 212 334 6820
Fax: +1 212 334 6822
info@frontstudio.com
www.frontstudio.com

Griffin Enright Architects
1246 Washington Blvd.
Los Angeles, CA 9006, USA
Tel: 310 391 4484
Fax: 310 391 4495
info@griffinenrightarchitects.com
www.griffinenrightarchitects.com

Group8
20 rue Boissonnas
1227 Acacias Geneva, Switzerland
Tel: +41 22 301 39 08
Fax: +41 22 343 41 24
info@group8.ch
www.group8.ch

Hanrahan Meyers Architects
135 West 20th Street, 3rd Floor
New York, NY 10011, USA
Tel: +1 212 989 6026
Fax: +1 212 255 3776
info@hanrahanmeyers.com
www.hanrahanmeyers.com

Hût Architecture Ltd
192 St. John Street
Clerkenwell
London EC1V3JY, UK
Tel: +44 (0) 20 7566 5333
info@hutarchitecture.com
www.hutarchitecture.com

I-Beam Design
245 West 29th St, Suite 501A
New York, NY 10001, USA
Tel: +1 212 244 7596
Fax: +1 212 244 7597
suzan@i-beamdesign.com
azin@i-beamdesign.com
www.i-beamdesign.com

Ian Moore Architects
44 McLachlan Avenue
2011 Rushcutters Bay, Sydney, Australia
Tel: +61 293 804 099
Fax: +61 293 804 302
info@ianmoorearchitects.com
www.ianmoorearchitects.com

José María Sáez
Galápagos OE3-196 y Vargas
Quito, Ecuador
Tel: +5932 295 6135
Fax: +5932 295 5434
2josemoni@gmail.com
www.arqsaez.com

KJD Architecture
536 SE 17th Ave.
Portland, OR 97214
Tel: 503-231-2884
Fax: 503-231-9521
www.kjdarch.com

La Dallman Architects
225 E. St. Paul Ave.
Suite 302
Milwaukee, WI 53202, USA
Tel: 414 225 7450
Fax: 414 225 7451
mail@ladallman.com
www.ladallman.com

Lyn Rice Architects
40 Worth Street 1317
New York, NY 10013, USA
Tel: +1 212 285 1003
Fax: +1 212 285 1005
LRA@LRAny.com
www.LRAny.com

Manuel Ocaña
Sagasta 23, 7º izda
28004 Madrid, Spain
mauelocana@manuelocana.com
www.manuelocana.com

Meixner Schlüter Wendt Architekten
Fischerfeldstraße 13
60311 Frankfurt am Main, Germany
Tel: +49 069/ 210286- 14
Fax: +49 069/ 210286- 20
info@meixner-schlueter-wendt.de
www.meixner-schlueter-wendt.de

NMDA, Inc.
12615 Washington Blvd.
Los Angeles, CA 90066, USA
Tel: +1 310 390 3033
Fax: +1 310 390 9810
info@nmda-inc.com
www.nmda-inc.com

Ofis Arhitekti
Kongresni Trg 3
1000 Ljubljana, Slovenia
Tel: +386 1 426 00 85 / 426 00 84
Fax: +386 1 426 00 85
projekt@ofis-a.si
www.ofis-a.si

Ogawa Depardon Architects
69 Mercer St, 2nd Floor
New York, NY 10012, USA
Tel: +1 212 627 7390
Fax: +1 212 431 3991
info@oda-ny.com
www.oda-ny.com

Rogers Marvel Architects, PLLC
145 Hudson Street, 3rd Floor
New York, NY 10013, USA
Tel: +1 212 941 6718
Fax: +1 212 941 7573
rrogers@rogersmarvel.com
www.rogersmarvel.com

SCDLP Architects
Charlotte Skene Catling
44 Lexington Street
W1F 0LW London
Tel: +44 207 287 0771
Fax: +44 207 439 1932
contact@charlotteskenecatling.com
www.charlotteskenecatling.com

Space4a
36 South 4 Street, Suite B9
New York, NY 11211, USA
Tel: +1 917 459 7448
Fax: +1 718 302 2231
twarnke@space4a.com
www.space4a.com

Syntax Architektur
Brandmayerstrasse 2
A-3400 Klosterneuburg, Austria
Tel +43 2243 3 28 49 00
Fax: +43 2243 3 28 49 01
office@syntax-architektur.at
www.syntax-architektur.at

Taylor Smyth Architects
354 Davenport Road, Suite 3B
Toronto, Ontario M5R 1K6, Canada
Tel: +1 416 968 6688
Fax: +1 416 968 7728
info@taylorsmyth.com
www.taylorsmyth.com

**Techentin Buckingham
Architecture, Inc**
201 S, Santa Fe Avenue 102
Los Angeles, CA 90012, USA
Tel: +1 213 437 0181
Fax: +1 213 625 1471
info@techbuckarch.com
www.techbuckarch.com

Tesgat Arquitectes
Avda. Diagonal 372, 2º 2ª
08037 Barcelona, Spain
Tel: +34 93 427 66 33
Fax: +34 93 459 01 22
tesgat@tesgat.com
www.tesgatarquitectes.com

Tidy Arquitectos
Marchant Pereira 407
Santiago de Chile, Chile
Tel: +56 2 223 84 89
info@tidy.cl
www.tidy.cl

UArchitects
Klokgebouw 233 5617 AC
Eindhoven, The Netherlands
Tel: +31 40 2366535
Fax: +31 40 2366541
info@uarchitects.nl
www.uarchitects.com

VMX Architects
Don Murphy
Staionplein 22
1076 CM Amsterdam
The Netherlands
Tel: +31 (0)20 676 1211
Fax: +31 (0)20 679 2455
info@vmxarchitects.nl
www.vmxarchitects.nl

Weysen and De Baere
Nieuwevaart 118/35
9000 Ghent, Belgium
Tel: +32 0498 28 21 85
edward.weysen@skynet.be

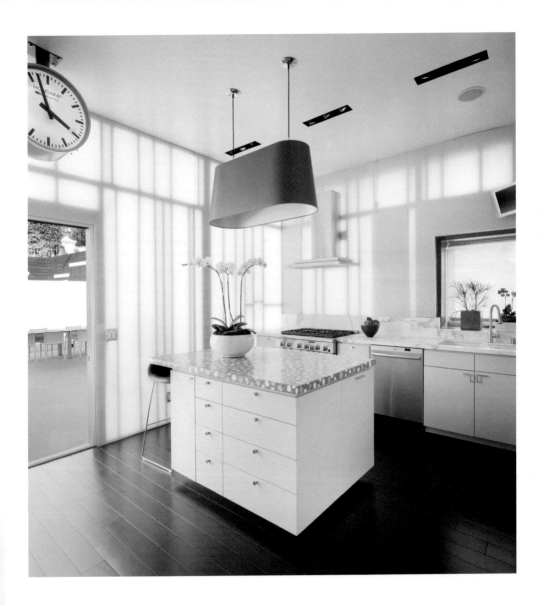

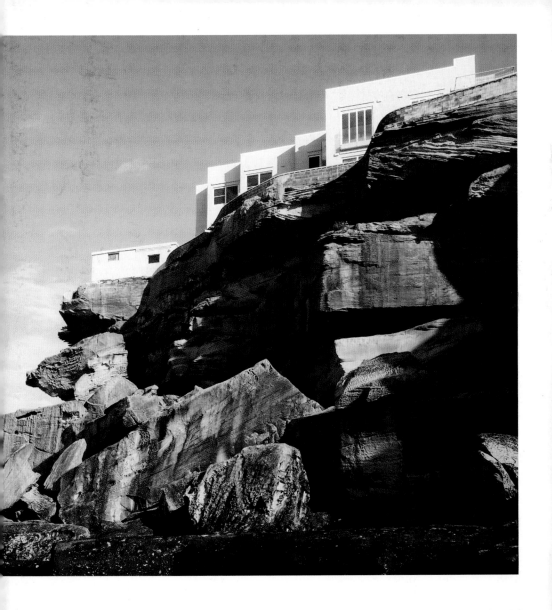